IMAGES
of America

NEW HAMPSHIRE'S CORNISH COLONY

Fern K. Meyers and James B. Atkinson

ARCADIA

Copyright © 2005 by Fern K. Meyers and James B. Atkinson
ISBN 0-7385-3753-5

First published 2005

Published by Arcadia Publishing,
Charleston SC, Chicago IL, Portsmouth NH, San Francisco CA

Printed in Great Britain

Library of Congress Catalog Card Number: 2004115395

For all general information, contact Arcadia Publishing:
Telephone 843-853-2070
Fax 843-853-0044
E-mail sales@arcadiapublishing.com
For customer service and orders:
Toll-free 1-888-313-2665

Visit us on the Internet at www.arcadiapublishing.com

CONTENTS

ACKNOWLEDGMENTS

Although the archival images in this book do not constitute a systematic illustrated history of the Cornish Colony, they amply illustrate the sense of people, places, and things associated with it. The authors are indebted to many individuals, historical societies, institutions, museums, and galleries for their friendly and generous cooperation, especially: the Cornish Historical Society and Hannah Schad; the Boston Symphony Orchestra and Bridget Carr; Dartmouth College and the staff of Special Collections at Rauner Library; the Harvard Musical Association and Nathalie Palme; Kimball Union Academy and Jane Fielder; the MacKaye family and Marion Ober; the Nichols House Museum and Flavia Cigliano; Peter Nyboer and family; the Plainfield Historical Society and Nancy Norwalk; the Saint-Gaudens National Historic Site and B. J. Dunn, Henry Duffy, and Gregory C. Schwartz; the Smith family; Spanierman Gallery of New York and Ralph Sessions; the Windsor Historical Society and Barbara Rhoad; and two people for their appreciation and love: Robert D. Meyers and Gretchen A. Holm.

In extending our gratitude, we have used the following abbreviations when identifying organizations in the photo credits that accompany the images in this book: CHS—Cornish Historical Society of Cornish, New Hampshire; PHS—Plainfield Historical Society of Plainfield, New Hampshire; SGNHS—Saint-Gaudens National Historic Site; and WHS—Windsor Historical Society of Windsor, Vermont.

INTRODUCTION

Writing almost 100 years ago, the earliest historian of Cornish described the landscape in words we might use today: "Cultured taste seems to admire the scenery of Cornish, as the variety of its scenery seems inexhaustible. Verdant hills, rich pastures, smiling meadows, and pure streams of water all combine to render it the seat of ideal homes. The hillsides and valleys, too, abound in springs of purest water, while beautiful forests crown the summit of most of the hills, and pure air breezes over all."

Those "beautiful forests" were what attracted the original settlers to the area. King George III of England issued a charter for what was to become the township of Cornish on June 21, 1763. Because some of the families of the 70 grantees were from the English mining area of Cornwall, the proprietors called the area Cornish. Since the area along the Connecticut River—the western boundary of Cornish—was known before 1763 as Mast Camp, the charter provided "that all White and other Pine Trees within the said Township fit for Masting our Royal Navy, be carefully preserved for that use." (England's White Pine Act of 1729 declared that all trees with a diameter of 24 inches or more were to be set apart for masts—this condition also extended to the King's colonies.) Furthermore, "Every Grantee . . . shall plant and cultivate five Acres of Land within the Term of five years for every fifty acres contained in his . . . Share or Proportion of Land in said Township, and continue to improve and settle the same by Additional Cultivations."

Thus, in one form or another, the landscape established the conditions for the early development of Cornish. Until late in the 19th century, the community thrived. Several considerations, however, restricted its prosperity. The relatively limited number of arable acres available to new settlers could not compete with the vast expanses found in the Midwest and Plains states. Farmers who were eager for greater opportunity gradually headed to those regions. Then, as urban wool markets, especially in Boston, began to draw on the larger supply of sheep in the West, sheep raising also disappeared from Cornish. Lastly, without the waterpower available in the larger towns nearby, such industry as there had been in Cornish lost ground. The census taken in 1890 confirmed what people were gradually coming to realize: the population had declined to slightly less than it had been in 1790.

Five years before that census was taken, however, another source of settlers cropped up. This new wave of homesteaders was pioneered by sculptor Augustus Saint-Gaudens, who in 1885 came to Cornish because it promised "plenty of Lincoln-shaped men" after whom he could model his statue *The Standing Lincoln* (now in Chicago). Other artists came to settle in Cornish,

New Hampshire, as well as in the neighboring towns of Plainfield, New Hampshire, and Windsor, Vermont. As is the case with most young, aspiring artists, the "Colonists" of this fledgling colony were in need of reasonable lodgings, which were readily available in the area.

Were a person 15 years ago to be casually described as belonging to "the Cornish Colony," only a few art historians specializing in American art would have had but an inkling of what the speaker meant. Well-known artists such as Augustus Saint-Gaudens and Maxfield Parrish might have been linked to the Colony, but even those "Colonists" would not necessarily have been associated with a village in western New Hampshire.

Today, however, there is much greater name recognition of the Cornish Art Colony. It has a cachet as unique as that of art colonies in Provincetown, Massachusetts, or New Hope, Pennsylvania, or Old Lyme and Cos Cob in Connecticut. Furthermore, even more individuals connected to the Colony have gained fame. These include Thomas Dewing, Willard Metcalf, Paul Manship, William and Marguerite Zorach, Percy MacKaye, Witter Bynner, Walter Damrosch, Arthur Whiting, Isadora Duncan, Ethel Barrymore, Marie Dressler, Louise Homer—even Pres. Woodrow Wilson.

This increased recognition for the Cornish Colony results directly from two factors. First, popular interest in the intellectual and literary life during "the Gilded Age" of the American Renaissance (roughly the 1880s and 1890s) has been keen lately. Second, such interest has, in turn, produced more informed publicity for the recent spate of exhibitions of late-19th-century American art. A century later we are, therefore, more aware of the artistic aspirations of this period and can better appreciate its art.

Now when people refer to "the Cornish Colony," they have in mind a group of sculptors, painters, poets, writers, and musicians who established the Colony's reputation. Some of these artists moved to Cornish only during the summer; others, known as "Chickadees," lived there all year long. It mattered not a whit whether the artists were from New York or Boston, local people indiscriminately referred to all the "city folk" in Cornish as "Little New York." On the one hand, the "natives" were glad for the extra income they earned by working as gardeners, carpenters, housekeepers, cooks, and caretakers for the Colonists. On the other hand, there were residents who felt that the Colonists exploited them.

In 1913, the International Exhibition of Modern Art, better known as the Armory Show, electrified the art world. Furthermore, in the early 1920s, the ravages of World War I altered the mind-set of many Americans. With the two notable exceptions of Marguerite and William Zorach, it is safe to say the kind of art that characterized the Cornish Colony did not survive these early-20th-century shocks.

Almost a century later, however, we are beginning to look at Cornish Colony art with greater equanimity. People's appetite for more information about the Colony has now been whetted. During its heyday newspapers pointed out that "to some New Yorkers" the Colony was known as "the Athens of America." The following archival illustrations, with their stamp of authenticity, should contribute to the reader's sense of place. Moreover, these images emphasize the social context of a significant period in American cultural history.

One

FERTILE GROUND
A LANDSCAPE IN TRANSFORMATION

In Cornish, the sturdy beauty of both land and people have remained a constant throughout its history. Nestled in a peaceful valley, settlers originally came to the area, as an early map put it, for "Choice White Pine and Good land." The fertile land and the rocky hills resulted in isolated homesteads. There has never been a town center. So the inhabitants were obliged to look to themselves for social interaction. This spirit of self-reliance and respect for the individual has existed side by side with the New England tradition of mutual concern and neighborly involvement.

The following images illustrate the geography and topography of the area. But they hide the gradual diminution of the agrarian economy. Yet, even when this loss combined with the movement away from sheep raising and with a series of economic depressions that marked the Gilded Age at the end of the 19th century, there was yet fertile ground in Cornish for a new crop: artists seeking reasonably priced property to rent or purchase. Hence the seed was sown for the Cornish Colony.

For almost 50 years the natural landscape and its people were gradually, gently, and gracefully transformed. Artists, writers, and musicians, many known far and wide for their accomplishments, found themselves in Cornish alongside a local population that had come through economic vicissitudes with heads held high. There were precious few squabbles because both groups admired a region that held profound human and natural virtues.

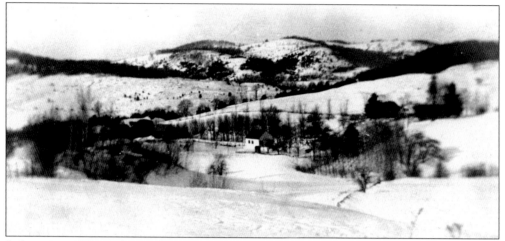

In his poem, "The Gift Outright," Robert Frost reminds us that "the land was ours before we were the land's." Colony members would have understood this "gift outright." All the open land seen in this image of the Goward School (at center) would have impressed them, but they probably would not have considered how far pupils had to walk between home and school. Today's residents, accustomed to forest and scrub, are amazed when they realize how many fields were once visible. (Courtesy CHS.)

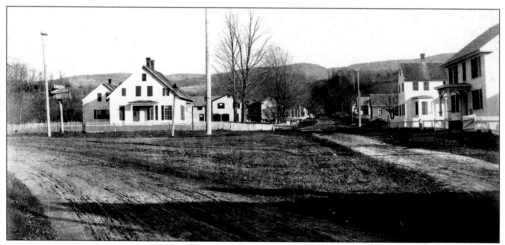

In the 1890s the area around the village of Cornish Flat seemed more open than it does today. The configuration of these roads has been maintained for over a century. Edith Rue Jewett Philbrick wrote, "Home of Grandma Jewett's sister Delilah," on the back of this image of Cornish Flat, looking east toward School Street. (Courtesy CHS.)

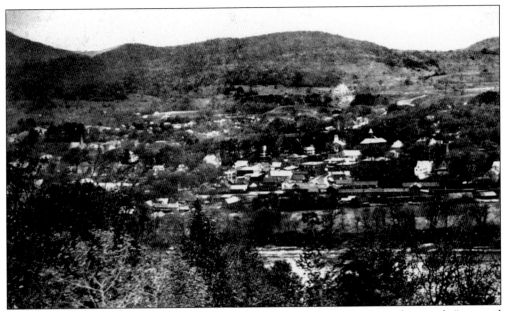

The western boundary of Cornish proves that the openness of "the gift outright" existed everywhere. This postcard shows Windsor, Vermont, as viewed from the Cornish hills. JMC (the postcard's writer) reported on November 30, 1913, that there had been quite a lot to do since "Lizzie was gone every day on the milk cart" and a mutual friend was unwell, perhaps because she had too much to do and not enough help. (Courtesy WHS.)

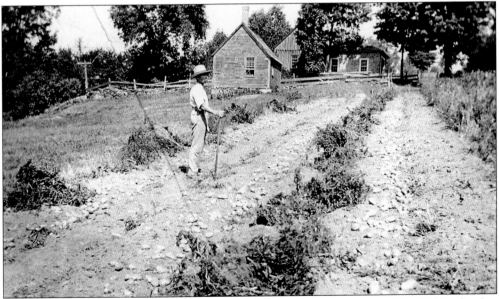

The primary use of the land around Cornish was for agriculture. Here Elwin W. Quimby digs his potato crop on the farm of his father-in-law, William Westgate. Elwin was a member of a quartet that sang at many local affairs, and his son, Arthur, played the organ at the Congregational church in Cornish Center. (Courtesy CHS.)

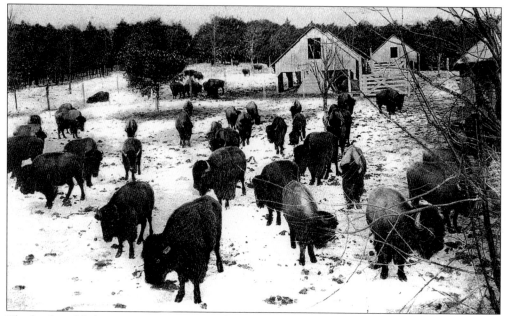

The land could also serve as pasture. We should not expect, however, that the Cornish Colony would graze merely conventional cattle. Here a herd of buffalo forages in the Blue Mountain Forest Association, which by 1887 stretched for roughly 40 square miles. The area is better known as Corbin's Park after its founder, Austin Corbin Sr., a successful lawyer, reorganizer of failed railroads, and founder of America's first national bank. (Courtesy CHS.)

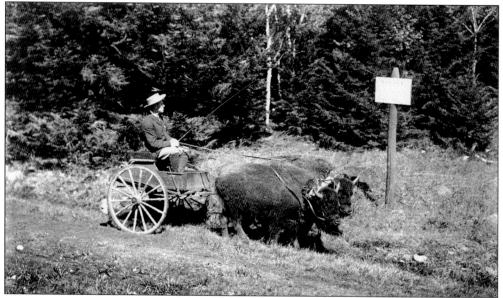

In 1904 Austin Corbin Jr. invited journalist Ernest Harold Baynes to supervise the wildlife of Corbin's Park. Even unconventional and unexpected animals were found to be useful. Seen at the reins here, Baynes was proud that he broke these two buffalo, named War Whoop and Tomahawk, to yoke, though their training cost him some "fine black eyes." The posted notice warns (though one would hope unnecessarily), "See that your Harness and Brakes are in order before starting down the Mountain." (Courtesy PHS.)

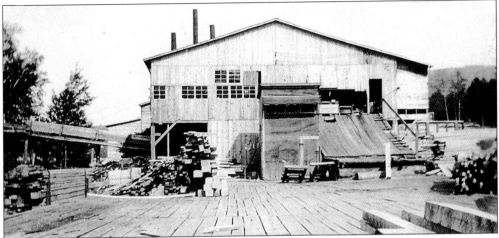

This mess hall at Corbin's Park fed the workers, a large staff, and Ernest Harold Baynes, a New York journalist interested in conservation and photography. His numerous glass slides document his and Austin Corbin Jr.'s ecological concerns. There were deer, elk, boar, antelope, caribou, bear, mountain goats, moose, and wolves in the park, but local people often referred to the entire area as Buffalo Mountain. (Courtesy CHS.)

The land around Cornish was also home to some logging operations. As farms were abandoned during the hard times of the late 19th century, forests often served as their own reclamation projects. The people who were responsible for managing Corbin's Park successfully were not above learning from the local population how to make the land pay dividends. This is a sawmill in Corbin's Park. (Courtesy CHS.)

Perhaps Austin Corbin Jr. learned some of the tricks of the logging trade from A. P. Butman, a Cornish resident who died in 1918. Here, Butman's Mill on Leavitt Road indicates how useful the area's brooks were not only for powering the mill but also for getting logs to it in the first place. (Courtesy CHS.)

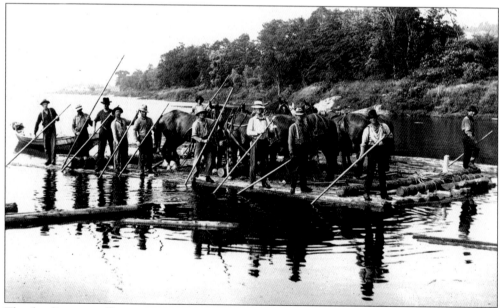

The land's most effective resource for the logging industry, and for supporting the local population, was the Connecticut River, which separates Cornish, New Hampshire, from Windsor, Vermont. However, logjams on the river were common hazards, requiring action by men and sometimes horses to free up the logs. The logjams could cause great destruction before the logs reached their destination at local mills. A log drive in 1897 destroyed the railroad bridge over the Connecticut River. (Courtesy WHS.)

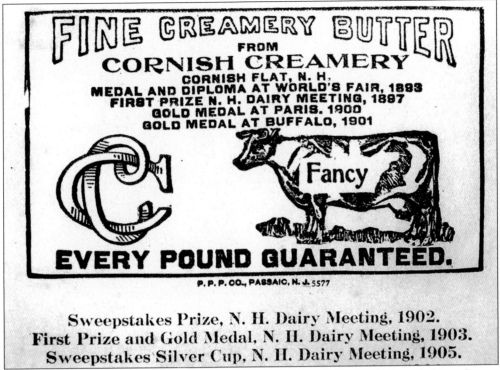

FINE CREAMERY BUTTER

FROM

CORNISH CREAMERY

CORNISH FLAT, N. H.
MEDAL AND DIPLOMA AT WORLD'S FAIR, 1893
FIRST PRIZE N. H. DAIRY MEETING, 1897
GOLD MEDAL AT PARIS, 1900
GOLD MEDAL AT BUFFALO, 1901

Fancy

EVERY POUND GUARANTEED.

P. P. P. CO., PASSAIC, N. J. 5577

Sweepstakes Prize, N. H. Dairy Meeting, 1902.
First Prize and Gold Medal, N. H. Dairy Meeting, 1903.
Sweepstakes Silver Cup, N. H. Dairy Meeting, 1905.

Two creameries operated in Cornish, which proves that the land around Cornish was sometimes used for conventional agricultural purposes. This butter wrapper was printed for the Cornish Creamery, a cooperative established in 1888 at Cornish Flat. Under the management of Edwin L. Child, the creamery entered the Pan-American Exhibition at Buffalo, New York, in 1901. Competing against 971 leading American and Canadian creameries, the Cornish Creamery won first honors in all but one category. (Courtesy CHS.)

Evidently Mr. Butman ran his mill on Leavitt Road quite successfully, and he was considered trustworthy. This itemized account of his purchases at the Cornish Creamery from the summer of 1901 was not billed until the following spring. Imagine such a business arrangement today—even for a maker of "Gilt Edge Butter." (Courtesy CHS.)

15

Conventional use of the land extended to raising hogs and chickens as well. Curtis F. Lewin and his family lived at this homestead. Many Cornish Colony residents patronized his meat and poultry business located at the south end of Prospect Hill in Plainfield. His account books furnish social historians with valuable evidence about everyday life in the artistic and local communities. (Courtesy CHS.)

Curtis Lewin's account book for July 29, 1898, shows his dealings with Colony families (Cox, Walker, Platt, Dewing, Houston, Kneisel, Par[r]ish, Prellwitz, Whiting, and Beaman). Lewin donated the land on which Plainfield built the Mothers' and Daughters' Club. Moreover, before Clarissa Davidge (a New York City patron of many Colony artists) restored the former Kingsbury Tavern for her home, Lewin used the ramshackle building as a henhouse. (Courtesy CHS.)

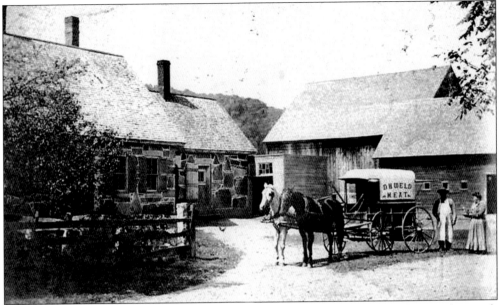

The farmer and butcher Daniel Weld also operated a meat market in Cornish. Here he stands with an unidentified woman beside his meat wagon. Weld died from a blow to his head on July 7, 1919. The home in the background has a fieldstone exterior. Although there are still a few fieldstone houses in the area today, they are not typical. The Enright Granite Works in Windsor, however, did quarry granite building blocks from Mount Ascutney. (Courtesy CHS.)

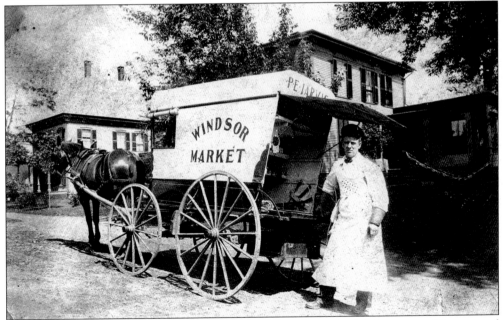

Peter Jarvis of Windsor also drew on the surrounding farms for his inventory. He operated the Windsor Market, known locally as the Jarvis Meat Market. Here he pauses briefly during his round of home deliveries. Jarvis exhibited his kindness by supplying suet to the Cornfield Bird Club (most of whose members were children), founded by Ernest Harold Baynes. (Courtesy WHS.)

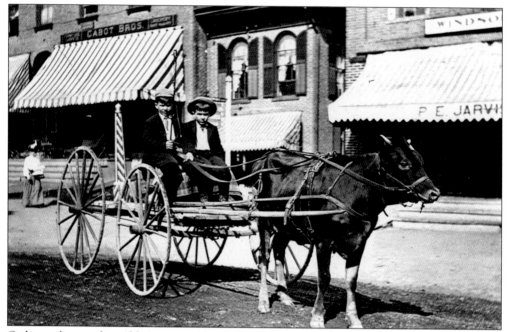

Ordinary livestock could sometimes be used in unusual ways. Did heads turn when William and Beaman Ayers drove this cart through the streets of downtown Windsor *c.* 1908? As an adult, Beaman Ayers operated the Windsor Machine Company (known later as the National Acme Company) and became its first vice president. (Courtesy WHS.)

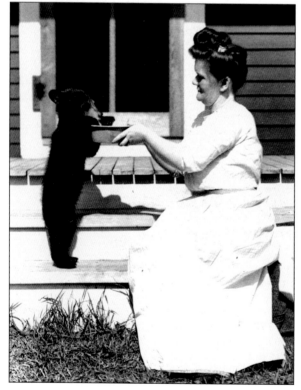

In the context of things unusual, here we find an animal being fed in an unexpected way. Lucy Mack, a housekeeper for Ernest and Louise Baynes, prepared daily meals for several remarkable boarders—even bottle-feeding some of them. At the dish is Jimmie, a bear cub Ernest Baynes raised, trained, and wrote about in a charming book entitled simply *Jimmie, the Story of a Black Bear Cub* (1923). (Courtesy PHS.)

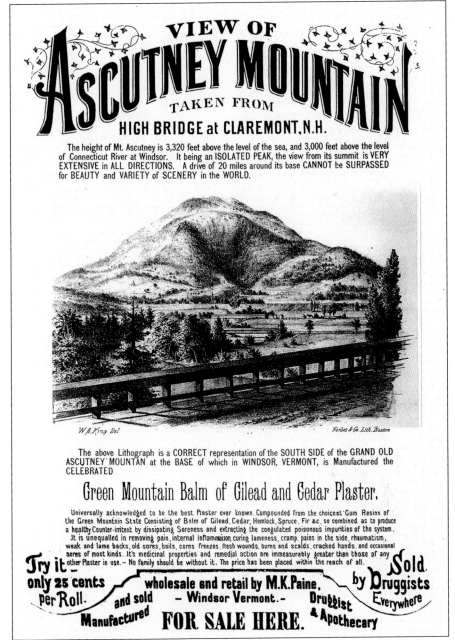

VIEW OF
ASCUTNEY MOUNTAIN

TAKEN FROM
HIGH BRIDGE at CLAREMONT, N.H.

The height of Mt. Ascutney is 3,320 feet above the level of the sea, and 3,000 feet above the level of Connecticut River at Windsor. It being an ISOLATED PEAK, the view from its summit is VERY EXTENSIVE in ALL DIRECTIONS. A drive of 20 miles around its base CANNOT be SURPASSED for BEAUTY and VARIETY of SCENERY in the WORLD.

W.A.King Del. Forbes & Co. Lith. Boston

The above Lithograph is a CORRECT representation of the SOUTH SIDE of the GRAND OLD ASCUTNEY MOUNTAIN at the BASE of which in WINDSOR, VERMONT, is Manufactured the CELEBRATED

Green Mountain Balm of Gilead and Cedar Plaster.

Universally acknowledged to be the best Plaster ever known. Compounded from the choicest Gum Resins of the Green Mountain State Consisting of Balm of Gilead, Cedar, Hemlock, Spruce, Fir &c, so combined as to produce a healthy Counter-irritent by dissipating Soreness and extracting the coagulated poisonous impurities of the system. It is unequalled in removing pain, internal inflammation curing lameness, cramp, pains in the side, rheumatism, weak and lame backs, old sores, boils, corns freezes, fresh wounds, burns and scalds, cracked hands, and occasional sores of most kinds. It's medicinal properties and remedial action are immeasurably greater than those of any other Plaster in use. — No family should be without it. The price has been placed within the reach of all.

Try it only 25 cents per Roll. and sold Manufactured **FOR SALE HERE.** wholesale and retail by M.K.Paine, — Windsor Vermont.- Druggist & Apothecary **Sold** by **Druggists** Everywhere

This advertising broadside for "Green Mountain Balm of Gilead and Cedar Plaster" purports to show "a correct representation of the south side" of Mount Ascutney. It does not. Not unlike their commercial brethren, Cornish Colony artists took some liberties in depicting the local landscape. Some people are convinced that they see images of Mount Ascutney in the works of Maxfield Parrish. As if he were viewing a Parrish painting, John Elliott wrote about Ascutney that it had "a deep plum colored bloom over it, so beautiful that it is beyond description." Area farmers, too, looked to the "mounting" and were dependent on it for meteorological advice. One farmer pointed out that if early in the morning there were "a cap on 'Cutney,'" he would have to hurry and get his haying done. (Courtesy CHS.)

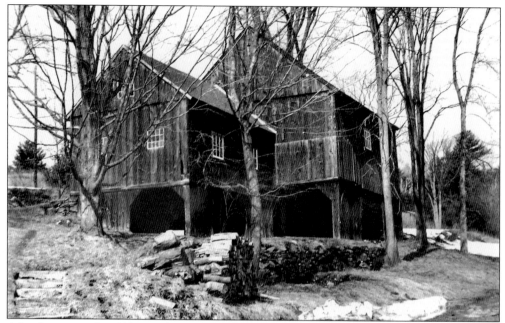

After he acquired a 105-acre farm on Stage Road, Plainfield, from Elmer DeGoosh in 1903, Herbert Adams converted the barns and outbuildings into studios, pictured here. In Plainfield Adams worked on some of the 160 commissions he was awarded during his career. For this property he hired Charles Platt to design his house, which Adams later named the Hermitage. (Courtesy Nyboer family.)

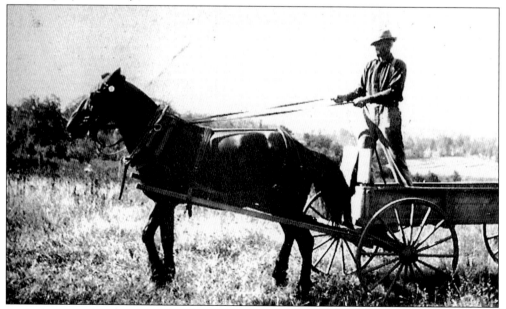

As is the case with many people who seek refuge from urban life by moving to the country, Percy MacKaye seems proud of his horse and wagon. A major figure in the revival of poetic drama early in the 20th century, MacKaye wrote a number of plays and poems while he was a boarder and tenant with Plainfield residents for nine years. He later built his own home, called Hilltop, in 1913. (Courtesy MacKaye/Ober family.)

20

Even Augustus Saint-Gaudens was not above harvesting the hay that grew on his property, Aspet. Named for the French town where his father was born, the house was a former inn, known as Huggins Folly, which was anything but comforting when he and his wife, Augusta, first saw it. "I first caught sight of the building on a dark, rainy night in April . . . it appeared so forbidding and relentless that one might have imagined a skeleton half-hanging out of the window, shrieking and dangling in the gale, with the sound of clanking bones. I was for fleeing at once and returning to my beloved sidewalks of New York. . . . My dwelling . . . stood out bleak, gaunt, austere, and forbidding, without a trace of charm. And the longer I stayed in it, the more its Puritanical austerity irritated me." Surely, as both Augustus and Augusta came to love the place, the hay harvest helped to diminish the property's "forbidding" appearance. (Courtesy SGNHS.)

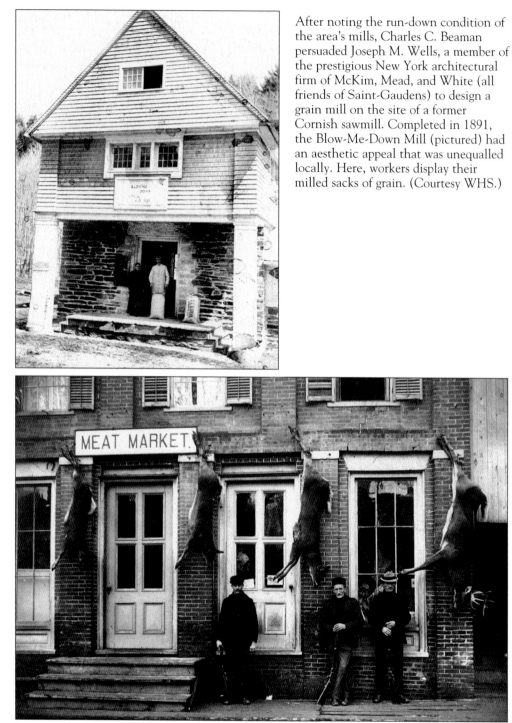

After noting the run-down condition of the area's mills, Charles C. Beaman persuaded Joseph M. Wells, a member of the prestigious New York architectural firm of McKim, Mead, and White (all friends of Saint-Gaudens) to design a grain mill on the site of a former Cornish sawmill. Completed in 1891, the Blow-Me-Down Mill (pictured) had an aesthetic appeal that was unequalled locally. Here, workers display their milled sacks of grain. (Courtesy WHS.)

In addition to serving the purposes of Colony artists, the Cornish landscape supported the local population as well. These unidentified hunters have had a successful day and proudly stand beside their trophies near a Windsor market. Perhaps they will help dress the deer and then receive their monetary reward from the butcher. (Courtesy WHS.)

22

Judging from her appearance, Mrs. Frances Huggins, who lived in Cornish Flat, was provided for quite well by her husband, George, a carpenter and builder. Many Cornish Colony residents relied on local craftsmen to provide basic utilitarian needs, to convert old farmhouses, and to create beautifully finished details for their new homes. For example, Edward S. Dannatt of Windsor produced well-proportioned, handsome cabinetry for many Colony residents. (Courtesy CHS.)

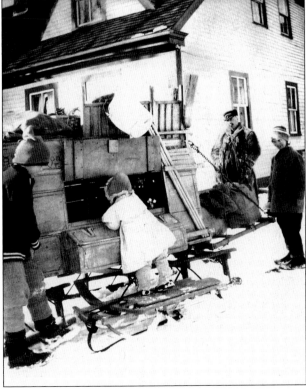

A warmly dressed peddler from White River Junction, Vermont, steps back while the children of Percy MacKaye inquisitively inspect the wares on his sleigh. These were likely to be common household goods that could be purchased from the peddlers as they made their rounds, which were more frequent in summer than in winter. (Courtesy MacKaye/Ober family.)

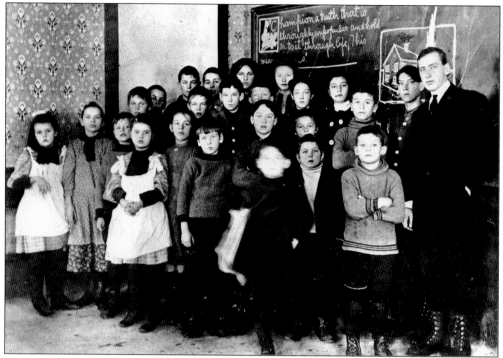

Posing with their teacher in front of the blackboard at Cornish Flat's one-room schoolhouse in 1908, these schoolchildren seem healthy, well dressed, and well scrubbed. Blackboards in the 21st century may play second fiddle to computers, but in the early 1900s they were an integral part of the classroom. This blackboard is inscribed with an apposite, inspiring quotation and a drawing of the school itself.(Courtesy CHS.)

WAR WORK
CORNISH LIBRARY CLUB

THE RESPONSIBILITY OF THE FARMERS

"Upon the farmers of this country, in a large measure, rests the fate of the war and the fate of the nations. . . . The time is short. It is of the most imperative importance that everything possible be done, and done immediately, to make sure of large harvests I call upon young men and old alike and upon the able-bodied BOYS of the land to accept and act upon this duty— to turn in hosts to the farms and make certain that no pains and no labor is lacking in this great matter."

WOODROW WILSON.

The interaction between the land, the local population, and Colony members may aptly end with this Woodrow Wilson quotation printed by the Cornish Library Club. Wilson lived in Cornish for three summers and frequently met his neighbors at church. He may have had them in mind when he wrote, "Upon the farmers of this country, in a large measure, rests the fate of the war and the fate of the nations." (Courtesy CHS.)

Two

COLONY MEN

LEADERS OF THE
AMERICAN RENAISSANCE

By the early 1900s most of the artists and sculptors of the Cornish Colony knew one another because they were fellow members of several elite New York City clubs. The first to come to Cornish, however, did not arrive with such ties. Augustus Saint-Gaudens, who attracted other artists to Cornish, came only because a patron told him he might find inspiration here. During the first decade of the Colony, Thomas Dewing, George de Forest Brush, Henry Oliver Walker, and Maxfield Parrish—artists whose works soon became visible in so many American homes— all attested to the spur Cornish gave their imaginations through its craggy landscape, craggy people, and bucolic tranquility. Members of the Cornish Colony were not all Gilded Age artists—Willard Metcalf and Ernest Lawson were Impressionists, and Everett Shinn belonged to the "Ashcan School."

Sculpture, too, was an early mainstay. Some sculptors came to study with and assist Saint-Gaudens, but many distinguished themselves through their own unique works. Herbert Adams and Frederick MacMonnies represented the Gilded Age; sculptor James Earle Fraser designed the "Buffalo" nickel for the U.S. Mint; and Paul Manship epitomized the Art Deco style.

Among the Colony's writers, Witter Bynner's poetry is still read, but Percy MacKaye's poetry and Winston Churchill's novels are all but forgotten. Learned Hand's judicial opinions are still admired for their meticulous detail, and Herbert Croly was a founding editor of the *New Republic*.

Resident and visiting composers, Arthur Whiting, Arthur Farwell, Edgar Stillman-Kelley, Sidney Homer, and Frederick Converse are hardly household names today, but their music deserves to be heard.

Cornish Colony members would have seconded the assertion made by their contemporary Henry James that "art makes life . . . and I know of no substitute whatever for the force and beauty of its process." Augustus Saint-Gaudens (pictured) once commented, "I thought that art seemed to be the concentration of the *experience* and *sensations* of life in painting, literature, sculpture, and particularly acting, which accounts for the desire in artists to have realism." When he came to Cornish in 1885, Saint-Gaudens had no idea that he was "founding" a colony or that it would flourish. He wrote in his *Reminiscences*: "Now there are many families. The circle has extended beyond the range even of my acquaintance . . . The country still retains its beauty, though its secluded charm is being swept away before the rushing automobile." (Courtesy Dartmouth College Library.)

As a sculptor, Augustus Saint-Gaudens was personally aware of the "force" needed to chisel "beauty" in the "process of art." Commissioned by historian and philosopher Henry Adams to commemorate his wife, Marion (who had committed suicide in 1885), the *Adams Memorial* is one of the best-known sculptures Saint-Gaudens created. This photograph of its brooding shape was taken while the monument was still in the Cornish studio. (Courtesy SGNHS.)

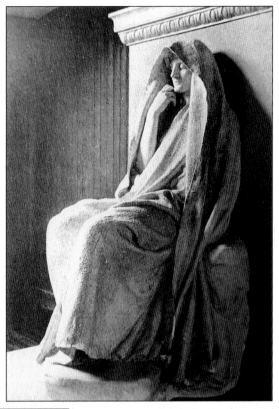

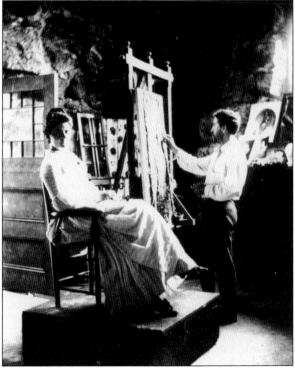

Fellow sculptor James Earle Fraser quoted Saint-Gaudens as claiming that in the process of art it is "the brain work not the finger work that takes the time." Here, in 1877, Saint-Gaudens is at work on a bas-relief of Frances Folsom Cleveland, wife of Pres. Grover Cleveland. Saint-Gaudens eventually produced a plaster sketch and, in 1892, a bronze medallion of Mrs. Cleveland in profile—looking younger and quite stately. (Courtesy SGNHS.)

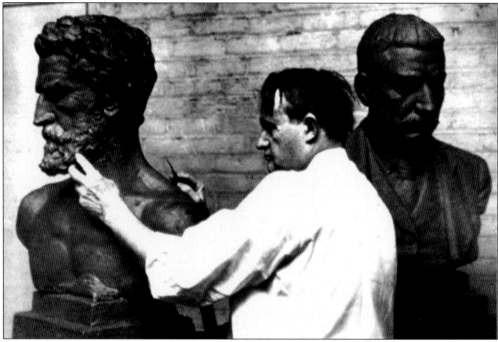

James Earle Fraser is best remembered for his 1913 design of the "Indian head" or "Buffalo" nickel. Here Fraser perfects a detail in his sculpture of his mentor, Augustus Saint-Gaudens— a bust commissioned for the Hall of Fame of Great Americans at New York University in 1926. In Cornish, Fraser assisted Saint-Gaudens on the *Sherman Monument* and the *Robert Louis Stevenson Memorial*. (Courtesy SGNHS.)

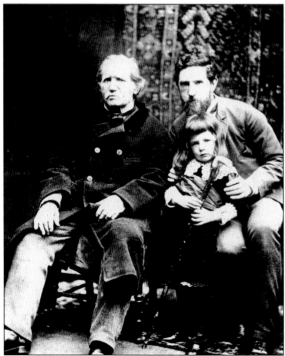

Augustus Saint-Gaudens (right) is pictured with his father, Bernard Saint-Gaudens, and son Homer on his knee. Bernard Saint-Gaudens (1816–1893) was a shoemaker born in Aspet, France. Bernard eventually immigrated to Ireland, where he married Mary McGuiness. The couple moved to America and settled in New York in 1848, when Augustus was only six months old. The sculptor's son, Homer Saint-Gaudens (1880–1958), wrote *The American Artist and His Times* and was the director of the Carnegie Institute's Gallery of Art in Pittsburgh, Pennsylvania. He also edited the two-volume *Reminiscences of Augustus Saint-Gaudens*. (Courtesy SGNHS.)

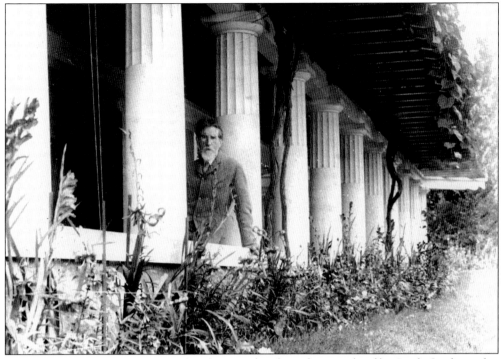

Augustus Saint-Gaudens peers at the photographer from the pergola of his Little Studio on his property in Cornish. In honor of his father, Saint-Gaudens named his place Aspet. Blooming gladiolas indicate that this 1906 image was taken in late summer. It is the last-known photograph of Saint-Gaudens, who died a year later, on August 3, 1907. (Courtesy SGNHS.)

According to Saint-Gaudens, the Cornish Colony began with the arrival in 1886 of Thomas Dewing, who was famous for his dreamy, ethereal landscapes populated by idealized women dressed in gossamer gowns. Apparently at least two people are required to "colonize."At Dewing's invitation, Henry O. Walker (pictured) came to Cornish in 1888. It is quite likely, then, that all three men would have agreed with Henry James that "art makes life." (Courtesy SGNHS.)

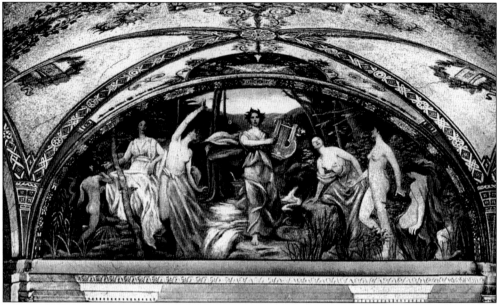

Henry O. Walker's greatest triumphs were his Library of Congress murals, which were commissioned in 1897. In one of those murals, *The Muse of Lyric Poetry* (pictured), the central figure is attended by Passion, Beauty, Mirth, Pathos, Truth, and Devotion. Samuel Isham, an art historian and critic, was delighted with these murals and believed that they "breath[ed] the very spirit of the lyric poetry they illustrated." (Courtesy CHS.)

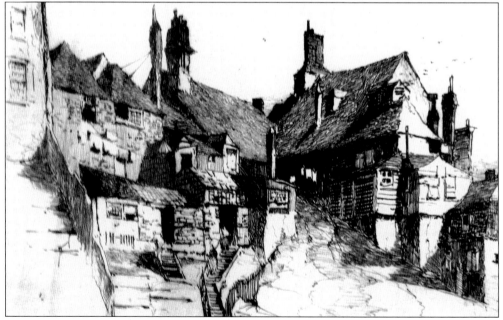

Walker convinced Charles A. Platt to come to Cornish in 1889; Platt built his own house, adjacent to Walker's, in 1890. Platt's interest in architecture, hinted at in this 1884 etching, entitled *Rye, Sussex*, would later blossom into a career as a distinguished architect. It would be quite a coincidence if one of these chimneys belonged to Lamb House on Rye's West Street, the place where Henry James lived after 1897. (Courtesy CHS.)

Charles A. Platt in turn persuaded Stephen Parrish (pictured) to come to Cornish. At first Parrish boarded with the Tracy family, but he later bought 18 acres across the road from them and began building his own home, which he called Northcôte. Parrish's initial fame rested on his etchings, but as the public's taste for purchasing etchings declined in the late 1880s, Parrish carried the day as a painter. (Courtesy Dartmouth College Library.)

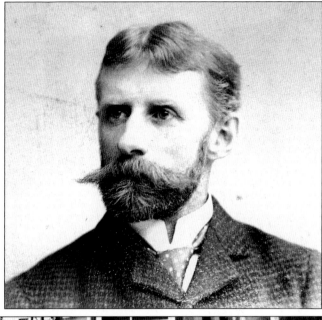

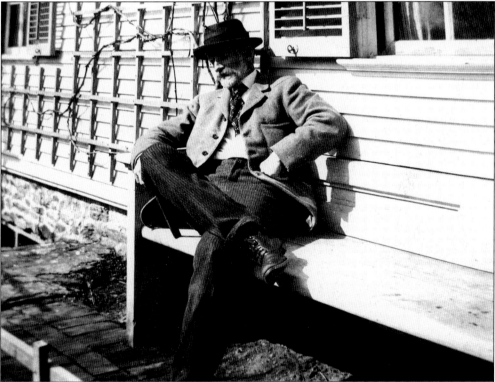

Stephen Parrish is seated on a bench at Northcôte. An engaging fact about Parrish is that he designed his house to face north; thus the kitchen, not the living room, faced Mount Ascutney—a house plan different from most others in the area. Parrish's diary is an invaluable source for details about the Colony's social scene. But he noted only facts, not a word of gossip to titillate future historians' curiosity. (Courtesy Dartmouth College Library.)

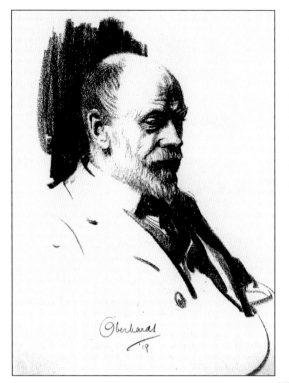

Interest in sculpture in the Cornish Colony was reasserted with the arrival of Herbert Adams and his wife, Adeline. Pres. Woodrow Wilson's first wife, Ellen, wrote her husband nearly daily in 1913, describing the Colony's social life. She pronounced, "Mr. and Mrs. Herbert Adams are among the choice spirits of the Colony—both intellectually and spiritually." This is a charcoal drawing of Herbert Adams sketched by William Oberhardt in 1919. (Courtesy Nyboer family.)

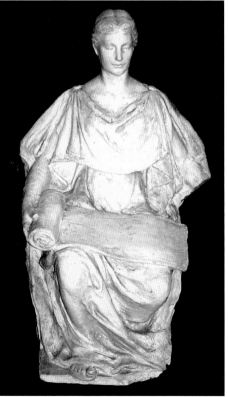

This plaster cast is for the figure Learning in Herbert Adams's *South Group* sculpture, which also included the figures of two youths, Science and Arts. These figures were created for the Pan American Exposition of 1901, held in Buffalo, New York, and were destroyed following the exhibition. Given the serious nature of this artwork, one might find it difficult to believe that Adams was an ace at charades, a diversion that many Cornish Colony residents indulged in with great verve. (Courtesy Nyboer family.)

Adams completed the plaster cast for *The Rabbi's Daughter*, left, in 1894. It was his diploma presentation at the National Academy of Design, whose founder and first president was Samuel F. B. Morse. (Associated with the invention of the telegraph, Morse actually began his career as a painter. He worked in Windsor and Cornish.) The cast on the right is a study for a portrait completed in 1913. (Courtesy Nyboer family.)

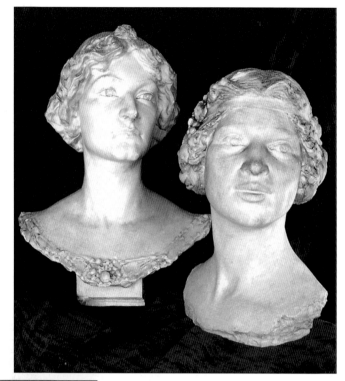

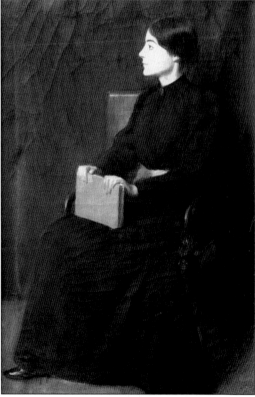

William Howard Hart was one of two Colony members who arrived on the scene in 1896. Hart was a landscape and portrait painter, and was a very close friend of Herbert Adams. On property adjacent to the Adams home, Hart remodeled an old New England farmhouse in a way that emphasized its hidden qualities. Hart painted several portraits of Adeline Adams. The one seen here looks much like her. (Courtesy Nyboer family.)

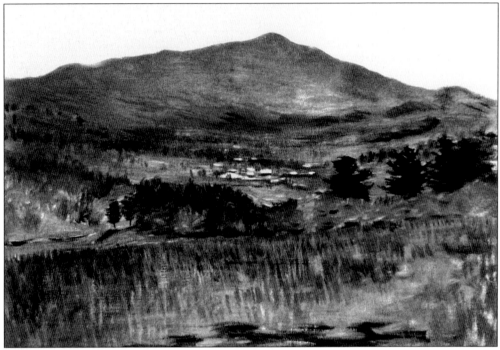

From his farmhouse in Plainfield, Hart painted several canvasses featuring the local landscape. This one shows the village of Plainfield in the foreground, and in the background is Mount Ascutney. Hart's other commitment—and the one for which he is best remembered locally—was local theater. He arranged, rehearsed, and staged plays in Plainfield. Instrumental in persuading the town to build a place to stage productions, Hart donated the latest in stage lighting for the theater. (Courtesy Nyboer family.)

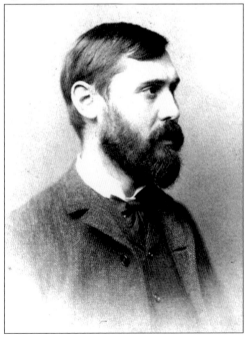

The other Colonists who arrived in 1896 were Kenyon and Louise Cox. They bought "a picturesque spot between woods and fields where the ground falls away toward a creek brawling beneath the antiquated dam of the one-time 'Freeman's Mill.'" In addition to being a famous muralist and painter, Kenyon Cox (pictured) was an art critic. His 1913 diatribe against the International Exhibition of Modern Art (the Armory Show) is frequently quoted. (Courtesy SGNHS.)

In 1897, Henry Fuller (pictured), a painter of allegorical works, settled in Plainfield with his wife, Lucia. The house they purchased was virtually destroyed by fire two years later. When they renovated their home, the Fullers added a swimming pool to the property, to the joy of many Colony members, especially the children. (Courtesy SGNHS.)

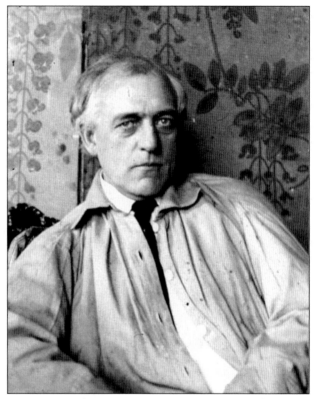

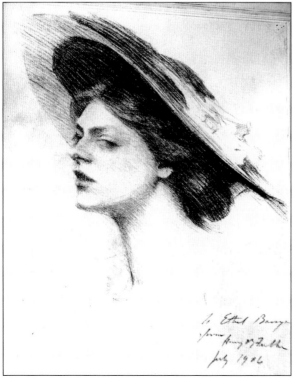

Henry Fuller did this sketch of actress Ethel Barrymore, who rented the Fullers' house in the summer of 1906. During his time as a Colonist, Fuller completed two famous paintings: *Illusions* (1901) and *The Triumph of Truth over Error* (1908). (Courtesy Dartmouth College Library.)

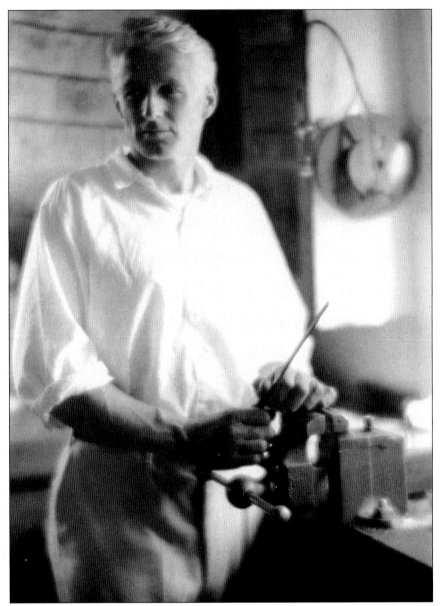

It was not until 1898 that Maxfield Parrish—who would become one of the Colony's most renowned representatives—heeded his father Stephen's wishes, came to Cornish, and bought land. The purchase price was advanced to him by his father. This image shows Maxfield Parrish beside his tool bench, in the guise he preferred. He described himself as "a machinist who paints pictures . . . I just happened to slide into painting as a profession. . . . The tool makers of the Connecticut Valley used to be famous, you know." He filled his home and studio with handcrafted brass latches, wooden furniture, and terracotta urns, which he often incorporated into his paintings. Parrish provided numerous illustrations for magazine covers, books, and businesses. Many featured groups of beautiful women in diaphanous gowns and (not without some irony on his part) self-caricatures. His commissioned murals, at sites ranging from Philadelphia and New York City to San Francisco, were among Parrish's most famous creations. (Courtesy Dartmouth College Library.)

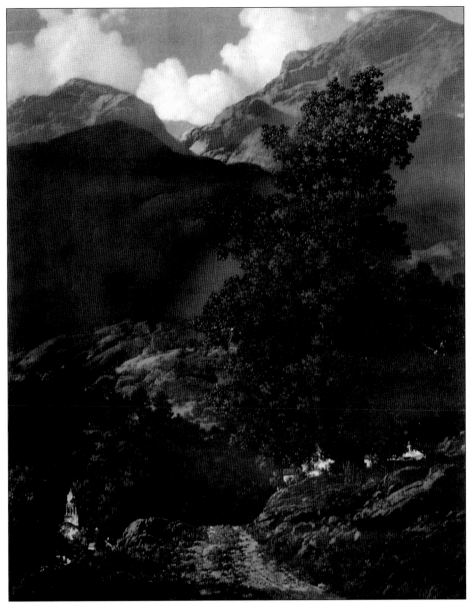

In 1931 Maxfield Parrish asserted: "I'm done with girls on rocks. . . . There are always pretty girls on every street, but a man can't step out of the subway and watch the clouds playing with the top of Mount Ascutney. It's the unattainable that appeals." Thanks to his special glazing process, his paintings gleam through meticulous brushwork; many feature his signature color, often referred to as "Parrish blue." This is an example of one of his later works, which, true to his word, were almost exclusively landscapes—often featuring local farms, area towns, and Mount Ascutney. This piece is a tintogravure entitled *Valley of Enchantment*, a work originally commissioned by Brown and Bigelow, a manufacturer of calendars and greeting cards, in 1943. This particular reproduction comes from a calendar published for Boston's Kistler Leather Company three years later. A caption behind the calendar includes the following words, a highly appropriate description of the type of painting Parrish did after 1930: "Mother Nature wields a magic brush over the countryside, and in her wake leaves a Valley of Enchantment." (Courtesy private collection.)

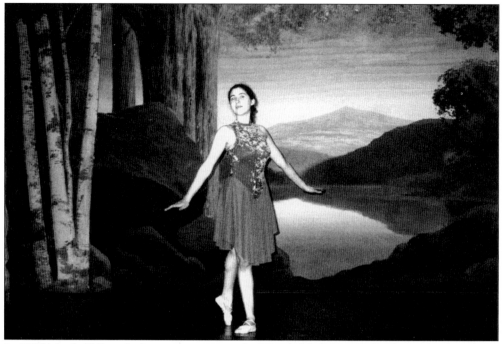

In 1916 Maxfield Parrish designed a stage set for Plainfield's Town Hall. The set has long been considered one of the most beautiful stages north of Boston. The inaugural production was *The Woodland Princess*, written by Maxwell Perkins's wife, Louise Saunders. Connoisseurs highly esteem Parrish's illustrations for Saunders's 1925 *The Knave of Hearts*. Here, Parrish's scenic backdrop can be seen behind Melissa Drye as she performs "The Peacock Dance" from Arthur Whiting's 1926 dance pageant for children, *The Golden Cage*. (Courtesy private collection.)

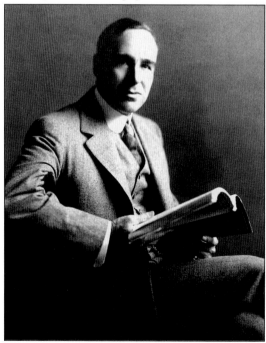

American novelist Winston Churchill (pictured) was one member of the Cornish Colony who proved that "the force and beauty of [art's] process" (as described by Henry James) is not restricted to painters and sculptors. Colonist Churchill, author of the novel *Richard Carvel*, was so famous that the "other" Winston Churchill wrote: "*Richard Carvel* is praised by everyone and I receive so many compliments because of it. . . . I promise . . . I will sign whatever I may write Winston *Spencer* Churchill." Throughout his distinguished political career he never broke his promise. (Courtesy Dartmouth College Library.)

This letter from Pres. Woodrow Wilson to the Colony's Winston Churchill, dated April 17, 1913, is the earliest indication that Wilson's "summer White House" would be located in Cornish. Churchill was considered to be the most popular author of fiction in America between 1900 and 1925. It was quite an undertaking for him to leave Cornish for the summers of 1913–1915 and stay in California so that he could rent his home, Harlakenden, to the Wilsons. (Courtesy Dartmouth College Library.)

THE WHITE HOUSE
WASHINGTON

W-15

April 17, 1913

My dear Mr. Churchill:

Thank you warmly for your generous letter of April ninth, which I greatly appreciate. It is a matter of genuine satisfaction to Mrs. Wilson and my daughters and myself that we are to be your tenants at Cornish. Your agent is doing everything possible to consult our convenience and wishes with regard to preparing the accommodations we need. I am sincerely obliged to you for your personal interest in the matter.

Pray accept my warmest thanks also for your generous personal words and good wishes concerning my administration. Such things greatly encourage me.

Cordially and sincerely yours,

Woodrow Wilson

Hon. Winston Churchill,
Santa Barbara, California.

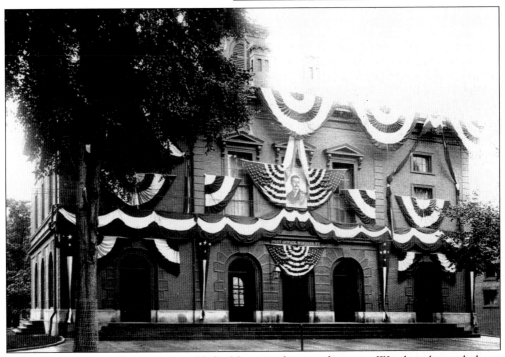

Wilson's executive offices were established here in the courthouse at Windsor, located above the post office; other members of his staff stayed across the street at the Windsor Hotel. The bunting, however, was not for Wilson. This picture was taken in June 1911, when former president Theodore Roosevelt was campaigning in Windsor during his Progressive Party's electoral challenge that, ironically enough, eventually lost to Wilson. (Courtesy WHS.)

After a day of hunting and a night spent in a Spartan clubhouse at Corbin's Park, it was in a carriage such as this that author Winston Churchill escorted Pres. Theodore Roosevelt on a tour past Harlakenden, through Cornish, over the covered toll bridge, and into Windsor, where the party attended a reception and horse show at the Windsor County Fair. It is unknown whether anyone had the audacity to charge this august group a toll. (Courtesy CHS.)

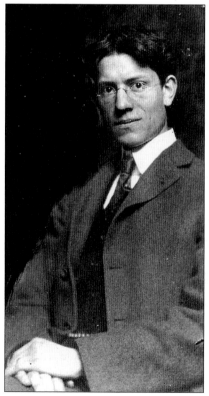

Colonist Percy MacKaye was another author who demonstrated that the force and beauty of art can extend beyond painters and sculptors. This rather formal portrait of MacKaye agrees with a description from an English visitor: "A divine fire burns in Percy MacKaye's soul and shines through his eyes—and I wish I could tell of the interesting, burning arguments we have had about War and Socialism." (Courtesy MacKaye/Ober family.)

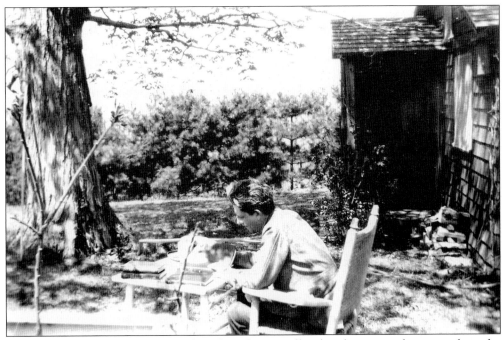

Percy MacKaye could also be happily informal, especially when he was working outside in the springtime. Although he was once honored throughout the country for his contributions to American culture, his fame has faded somewhat through the decades. Nevertheless, when Maxfield Parrish learned MacKaye had been appointed a poet-in-residence, he declared, "Percy is the best possible person to be a poet-in-residence, because he's a poet twenty-four hours a day." (Courtesy MacKaye/Ober family.)

Composers were also among the artists in the Cornish Colony. Arvia MacKaye, daughter of Percy, sculpted this bust of composer Edgar Stillman-Kelley (who is standing next to his likeness). In fact, Arvia's father and Kelley had a different kind of "Colonist" as a common ancestor: William Bradford, who arrived on the *Mayflower* and became governor of the Plymouth Colony in 1621. Composed exactly 300 years later, Kelley's *New England Symphony* is based on quotations from Bradford's logbook. (Courtesy MacKaye/Ober family.)

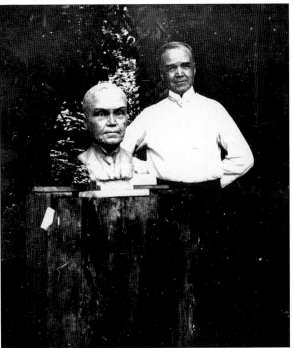

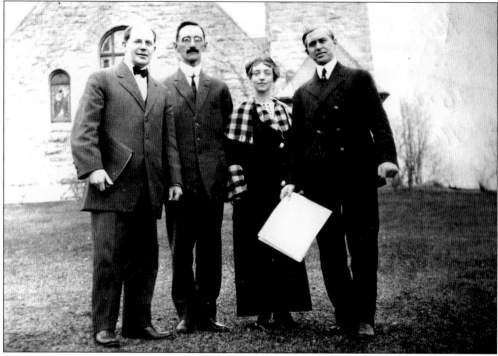

Arthur Farwell, another composer friend of the MacKayes, holds the score for his *Pageant of Meriden*, composed in 1913 for the 100th anniversary of Kimball Union Academy. With Farwell are, from left to right, pageant master William Chauncy Langdon, headmaster Charles Alden Tracy, and Miss ? Randall. The composition was based on the history of both Plainfield and Kimball Union, and also incorporated some of MacKaye's poem "School." (Courtesy Kimball Union Academy.)

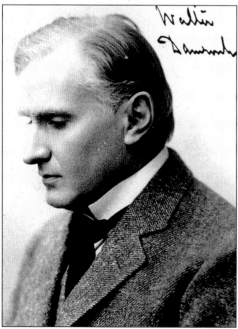

Walter Damrosch (pictured) was a famous conductor of the New York Philharmonic and Metropolitan Opera. He championed composers such as Wagner, Tchaikovsky, Mahler, and Elgar, as well as Americans Edgar Stillman-Kelley and George Gershwin. Damrosch hosted the *Music Appreciation Hour* broadcast weekly on NBC radio. He also composed incidental music for MacKaye's *Canterbury Pilgrims*. In the early 1920s, Damrosch rented High Court, a house Charles Platt designed in Cornish. (Courtesy private collection.)

Three

COLONY WOMEN
AHEAD OF THEIR TIME

Cornish Colony artists were not only male. The Colony women supported their husbands' careers, but many of them also were important artists in their own right; until recently, however, they have been little remembered. Louise Howland King Cox, Maria Oakey Dewing, Lucia Fairchild Fuller, Frances Grimes, Elsie Ward Hering, Edith Mitchell Prellwitz, Annetta Johnson St. Gaudens, Florence Scovel Shinn, and Bessie Potter Vonnoh, for example, are just now beginning to receive detailed and well-deserved attention from art historians examining the contributions to American art made by these women.

Not all the important women of the Cornish Colony were artists or sculptors. The writings of Adeline Pond Adams on sculpture, of Frances Duncan and Rose Standish Nichols on gardens and gardening, of Lydia Austin Parrish on ethnomusicology in her *Slave Songs of the Georgia Sea Islands*, and of Ellen McGowan Biddle Shipman on landscape architecture are still read and admired as standards in their fields.

Women's political action was not neglected in the Colony. The Cornish Equal Suffrage League announced its goals as early as December 1, 1911. It was "the second largest in the state, having at present sixty-eight members . . .[with] annual dues of fifty cents." (Nine of the twenty-seven founding members, however, were men.)

Nevertheless, the women of Cornish cannot be isolated from their times. In that era many married women buried their own artistic talents and willingly took a backseat to their husbands' careers. Though they were striving for political, cultural, and personal autonomy, the women did not want to upset any applecarts while they were at it.

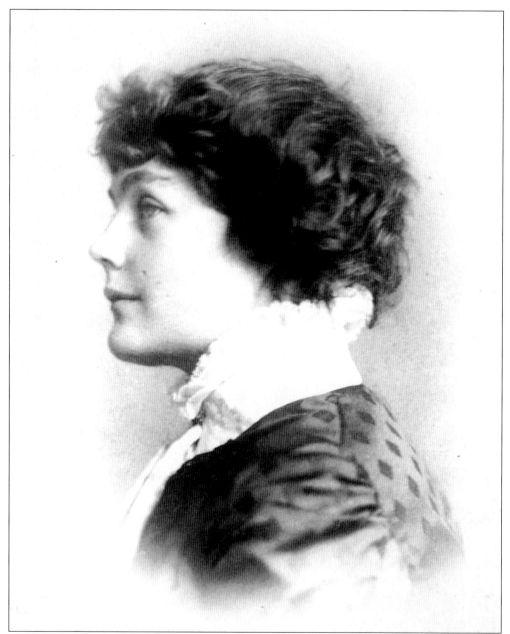

The artistic women of the Cornish Colony would have understood essayist Walter Pater's belief that "art comes to you proposing frankly to give nothing but the highest quality to your moments as they pass." This classic beauty is Adeline Pond Adams. Trained as a sculptor, she is also remembered for her writings about sculpture, *The Spirit of American Sculpture* (1923, 1929). In the context of the advisability of seeing sculpture in a domestic setting, as opposed to a museum, Adams observed: "One of the paradoxical effects of democracy is this: that with its liberating impulse toward a higher life, too many of us hasten to consider ourselves fitted for doing the highest things. But is it not true that a little medal or portrait may unfold more of the living spirit of art than a huge, shapeless, public monument? If we really believe this truth, sculpture may without condescension declare itself among the house-broken arts." (Courtesy Nyboer family.)

Adeline Adams sometimes modeled for and assisted her husband, Herbert. This is a plaster cast of *Flora*, completed in 1898, a piece on which they both worked. Together with *Bacchus*, the cheerful pair of garden herms occupied a place under the pergola and performed their function as guards to the Adamses' studio, located behind their house. (Courtesy Nyboer family.)

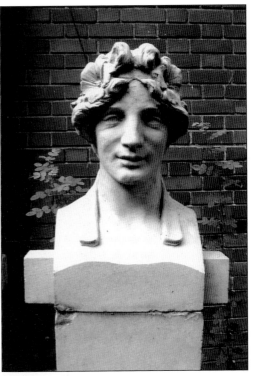

Here, William Howard Hart has painted Adeline Adams as a writer. In addition to writing poetry, especially two collections about the deaths of her daughters, *Mary* (1900) and *Sylvia* (1912), Adams's articles and reviews of sculpture were widely published. The fireplace mantel and pastel-green walls suggest Adeline posed in Hart's cottage, located behind the Adams home. (Courtesy Nyboer family.)

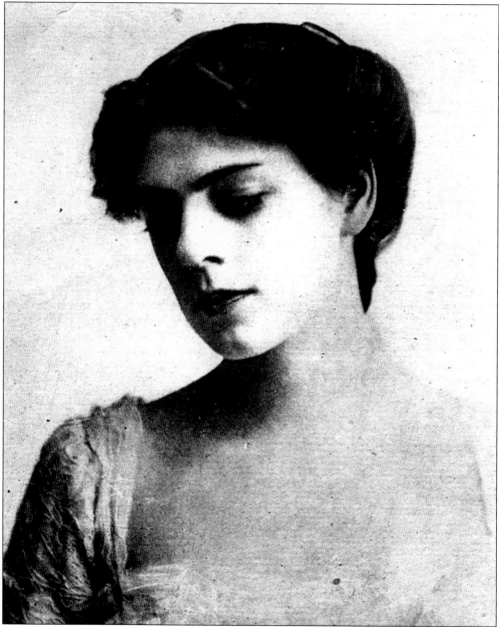

A whirlwind of social activity greeted Ethel Barrymore's appearance in Cornish in 1906. She was the center of attention at many parties; even the shyest of men were energized into lively conversation. In her *Memories*, Barrymore described Cornish as "A place of beautiful gardens where many artists and authors lived. To me the most exciting of them was Saint-Gaudens. He was then doing his wonderful *Lincoln*, he used to let me watch him work. The head was finished, and I never could look at it without wanting to cry . . . I always felt a great privilege to have known him." (The sculpture in question is the *Seated Lincoln*, now in Chicago's Grant Park.) Barrymore also commented on the art of several other Colonists. After viewing Kenyon Cox at work, she was particularly struck by his "enormous studio, and by his climbing ladders to do his huge canvasses. I had never seen anyone doing a big mural before." (Courtesy private collection.)

> "Summer done —
> Autumn begun —
> Farewell summer
> I do not know I'm away more"
>
> *Ethel Barrymore* —
> Cornish. Aug 28 - 1906
> Tuesday evening ——

Pictured is the entry Ethel Barrymore wrote in Percy MacKaye's guestbook when she visited him in the summer of 1906. Before Ethel descended on the Colony, Percy's wife, Marion, had expressed some apprehension: "I expect to enjoy her, but I rather dread the crowd she will have about her." About Barrymore's tennis court, Marion added, "When one can't talk to her guests one can doubtless return tennis balls to them." (Courtesy MacKaye/Ober family.)

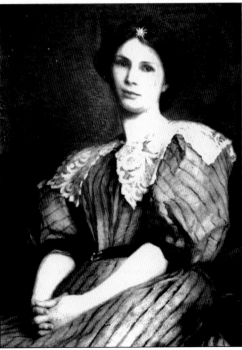

Kenyon Cox painted this portrait of his wife, Louise. A student of Thomas Dewing, Louise developed an excellent reputation for her paintings of flowers and children. The Coxes named their Cornish property Monarda, the botanical name for the numerous bee balm plants in their fields. In 1898 the novelist Theodore Dreiser pointed out in a review of Louise Cox's exhibited work, "[It] is now receiving proper recognition." (Courtesy SGNHS.)

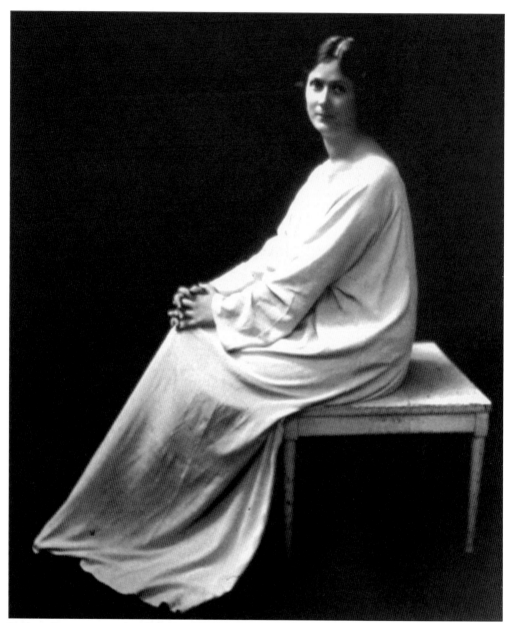

Isadora Duncan was the darling of high society, performing in Newport and for New York socialites—even for Queen Victoria. Often dancing barefoot, Duncan was renowned for her innovative interpretations presented while attired in filmy, flowing gowns. In her late forties, she danced for Colony residents at Maxfield Parrish's home, The Oaks. Following the performance, Parrish whispered to his father, "Her knees rang out like pistol shots." Percy MacKaye's description of Duncan earlier in her career was a bit more rhapsodic: "On the night of Isadora Duncan's first appearance at the Metropolitan Opera House [William Vaughn] Moody, George Grey Barnard, and I sat together there, spellbound as by some vision out of Beethoven's mind become there unbelievably corporeal; and afterward in Isadora's blue-curtained studio at the Windsor Arcade I introduced to her our groups of poets whom her autobiography refers to as 'young revolutionists.'" (Courtesy SGNHS.)

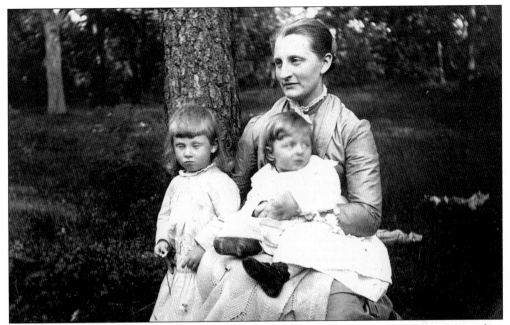

The Evarts family of Windsor was closely connected with the Cornish Colony. Married to Edward Perkins, Elizabeth Evarts Perkins here holds her children, Edward Jr. (left) and Maxwell. Maxwell, named for his maternal grandfather, William Maxwell Evarts (a friend of Augustus Saint-Gaudens), married Louise Saunders, a dramatist, short-story writer, and poet beloved for her book *The Knave of Hearts*, illustrated by Maxfield Parrish in 1925. (Courtesy WHS.)

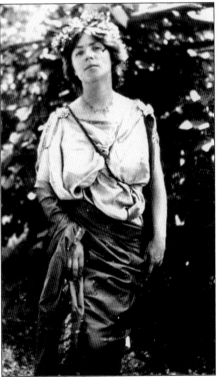

Lucia Fuller poses in 1905 as the Roman goddess Proserpina, in *A Masque of "Ours": The Gods and the Golden Bowl*. Henry and Lucia Fuller built and decorated a chariot that was used to usher Augustus and Augusta Saint-Gaudens from the masque to a reception. Later in her career, Lucia focused on painting miniatures. In 1899, she founded the American Society of Miniature Painters and remained president of that organization until 1913. (Courtesy SGNHS.)

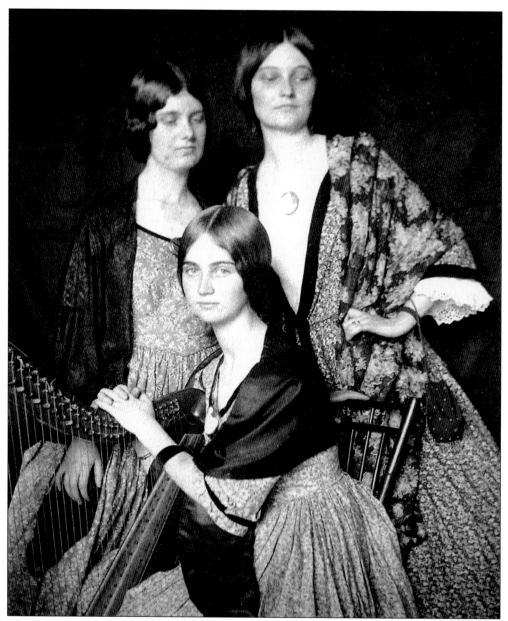

The Fuller sisters, Dorothy (left), Rosalind (center), and Cynthia—no relation to the family of painters—set the Colony on its collective ear when they visited in 1915. Their tour throughout America contributed to a growing interest in ballads and folk songs. To ensure that the audience for their Cornish performance was restricted to only local people, "Guards were stationed along the road to turn city folk away and none got by." An account of one of the Fuller sisters' local performances enthused: "The Townhouse was all scrubbed and shining, and the windows all open—nailed open. Thick-set wild flowers hid the fact that dangerous night air was entering. The doorkeeper urged the aged to keep their overcoats. The erring farmer Barton was there with his precious fiddle, and Deacon Wark with his, and octogenarian Amos Spaulding, when his turn came, took off his black coat and sitting, shirt-sleeved, beat an intricate kind of 'Peas Porridge Hot' on his knees to the time of the fiddling." (Courtesy MacKaye/Ober family.)

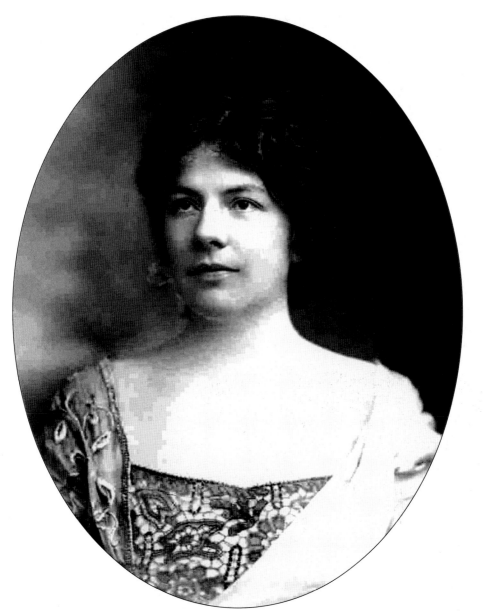

Sidney and Louise Homer rented Barberry House near Aspet in order to be near Sidney's cousins, Augusta Saint-Gaudens and Rose and Margaret Nichols. Madame Homer (pictured) spent the summer preparing for her role as Venus in the Metropolitan Opera's production of Wagner's *Tannhauser*. Louise was the leading contralto with the Metropolitan for 19 years, and also made some of the earliest recordings for the Victor Talking Machine. Her 1919 advice for women interested in a musical career is equally pertinent today: "I think it most important that girls should not drop their music after marriage, but it seems to me that much of the trouble comes before they have ever thought of marriage. They practice, go to their lessons, 'learn their pieces' (and promptly forget them), but they do not use their music for the entertainment or uplift of their families. . . . Either they practice too hard, and want to forget it when they have done their allotted amount of study, or they do not know how to make it practically useful." (Courtesy Boston Symphony Orchestra.)

Urged by Thomas Dewing to come to Cornish, Frances Houston and her family decided to visit and then stayed. Respected for her portraits, Frances studied in Paris at a time when few women did so. The sculptor Frances Grimes considered the Houston home, known as Crossways, one of the "more luxurious" in the Colony. Here we see the 1905 exhibition of Houston's paintings hanging at Boston's prestigious St. Botolph Club. Her obituary in a

Boston newspaper valued Houston's "extraordinary talent, her unusual technical ability, and her exquisite sense of beauty [that] all met with an immediate recognition. . . . She was an artist of immense range; her portraits show a rare strength and feeling for character, with a delicacy and charm of handling and of color which are missed in most of the art of our day." (Courtesy Dartmouth College Library.)

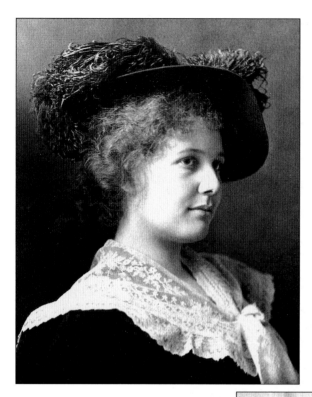

Marion MacKaye (pictured), who studied music in Boston with composers George Chadwick and Edward MacDowell, was an accomplished pianist and musician. Marion's lifelong friendship with Marian MacDowell led her and Percy to help start the MacDowell Colony in Peterborough, New Hampshire. She taught school, was an avid reader, and enjoyed writing prose and poetry. Marion's dramatization of Jane Austen's *Emma* was produced posthumously, in her memory. (Courtesy MacKaye/Ober family.)

Art's gift of "nothing but the highest quality" (in the words of Walter Pater) reminds one of Arvia MacKaye. Like her mother, Marion, and siblings, Arvia possessed many talents. She played the piano, and was a gifted sculptor and writer. Furthermore, she was a woodblock artist and collaborated with her father while utilizing her printmaking skills. Here Arvia relaxes at Hilltop, with Louise Cox's 1906 portrait of her as a young child in the background. (Courtesy MacKaye/Ober family.)

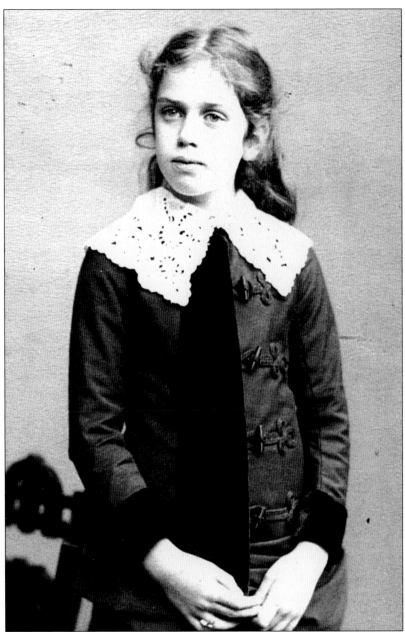

Rose Nichols was one of the earliest landscape architects in the United States—quite a feat for a woman then. She studied in Europe, and with additional assistance from her Cornish neighbor, Charles Platt, Nichols learned to do architectural layout. After spending a "stimulating" summer in Cornish, she persuaded her father, a prominent Boston physician, to acquire property in Cornish so that she could be part of the scene. It would be hard to predict, merely on the basis of this photograph of Nichols as a young girl, that she would go on to distinguish herself in fields other than landscape architecture. Her intellectual pursuits, for example, were widespread and grounded in firm convictions: "It was the spirit of the Puritans to try to broaden their interest toward wide horizons, and that same spirit I've tried to keep alive in everything I've ever done." (Courtesy Nichols House Museum, Boston.)

At Mastlands, home of the Nichols family, Elizabeth Nichols admires her daughter's garden, an outdoor laboratory for Rose's books and articles about garden design. Just as so many of her Cornish neighbors were women with special talents, so was Rose Nichols. Her progressive views introduced her to many of the illustrious artists, scholars, scientists, and theologians of her day. Also, Rose's commitment to the peace movement was strong. (Courtesy Nichols House Museum, Boston.)

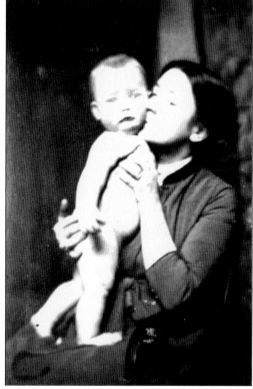

The painter and poet Laura Walker was photographed with her son Marq as they posed for *Mother and Child*, a painting by Laura's husband, Henry. As newlyweds in 1888, the Walkers rented Aspet, where they tended the gardens of Augustus and Augusta Saint-Gaudens. Laura wrote, "It was lonely but very pleasant up there." The Walkers enjoyed Cornish enough to purchase land nearby and were the first of the Colonists to ask Charles Platt for a house design. (Courtesy Smith family.)

Laura Walker actively participated in the Colony's social life. In 1897 she was among those who founded the Mothers' and Daughters' Club in Plainfield, and she contributed designs for the rugs the club produced. Laura and Henry offered their property for the production of Thackeray's comedy *The Rose and the Ring*, which was presented by some of the Colony's children in 1906. Afterwards, the Walkers hosted a tea. (Courtesy Smith family.)

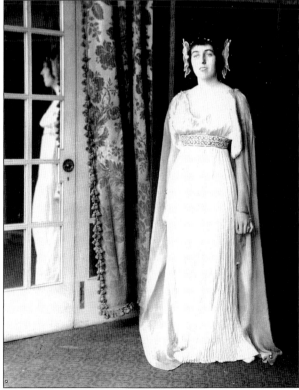

Eleanor Wilson is artfully posed in her costume for *Sanctuary: A Bird Masque*. A reviewer said of her performance: "Miss Wilson . . . displayed unusual dramatic skill and was a surprise even to her closest friends . . . the artistic expression which she put into [her] lines and the appealing tones with which she voiced the pleas of the bird spirit brought hearty applause from the enthusiastic audience." (Courtesy Dartmouth College Library.)

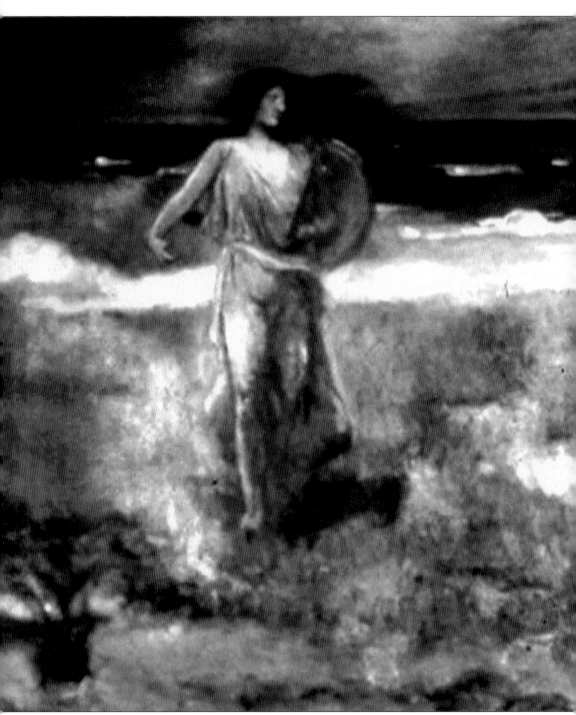

Edith Prellwitz perfected her painting skills in Europe and at the Art Students League in New York. At the League, Prellwitz studied with two other Colony artists, Kenyon Cox and George de Forest Brush, who urged her to enter the school's Life Class—daring advice for a young girl, since she would have to paint from nude models. This is Prellwitz's large allegorical painting *Elegy*, completed in 1908 and then exhibited at the National Academy of Design. Both figures

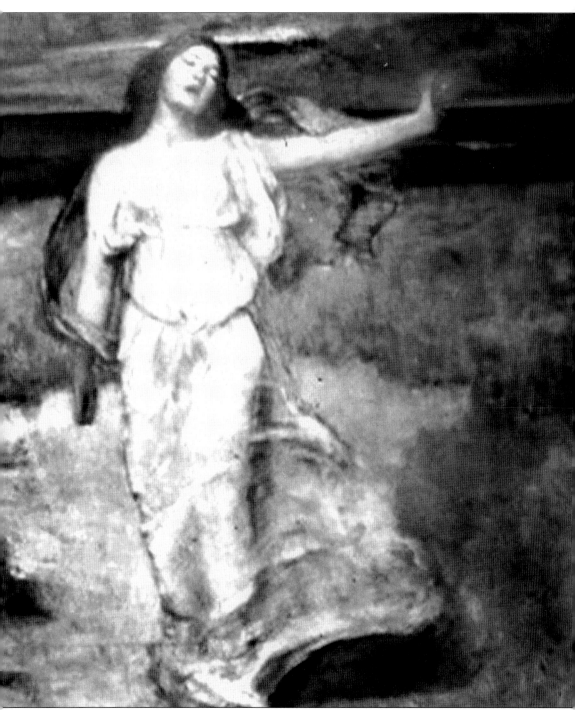

here, but especially the center of attention (which Prellwitz called Fate), are depicted in costumes similar to the ones worn by the Fates in the 1905 *A Masque of "Ours": The Gods and the Golden Bowl*, which honored Augustus Saint-Gaudens. So it is tempting to see this painting as a tribute to Saint-Gaudens, whose death in 1907 left a deep void in the spirit of the Colony. (Courtesy Spanierman Gallery.)

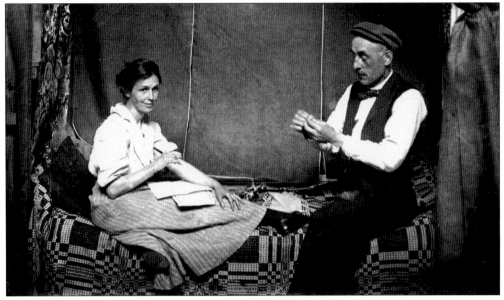

Annetta St. Gaudens enjoys a relaxing moment with her husband, Louis, Augustus's younger brother, who was also a sculptor with a national reputation. Augustus singled out Annetta to work as an assistant in his sculpture studios in New York and Cornish. Eventually she became Louis's trusted assistant. Her interests expanded to social concerns and ceramics; she opened Orchard Kiln Pottery with son Paul on their Cornish property in 1921. (Courtesy SGNHS.)

We may know Florence Scovel Shinn as an illustrator and writer, whose 1925 *The Game of Life and How to Play It* has been reprinted 42 times, most recently in 2001. But the jacket of that book describes Shinn as artist, illustrator, metaphysician, and lecturer. This is an illustration she did for Winston Churchill's 1906 novel *Coniston*, a book full of colorful New Hampshire figures in fictionalized towns around Cornish and its environs. (Courtesy CHS.)

Four

"A PLACE IN THE COUNTRY"

GRAND AND SIMPLE

Throughout history, people have aspired to own "a place in the country." Cornish Colony members were no exception. Unfortunately, most of them arrived without enough money to either purchase a place or build one. As William H. Child, the town's first historian wrote, "With scarcely an exception, most of the residents, . . . a sociable, unsophisticated group . . . live[d], after the fashion of artists, to the extent of their incomes."

In those early days, many in Cornish lived as boarders. Among the first to welcome such visitors was George Ruggles, who later became a dear friend of Maxfield Parrish. In 1891 Ruggles built the Woodchuck Hole, a studio with a large window facing north, three rooms, and a porch on two sides that delighted several writers, sculptors, and painters.

More elegant "cottages" (though not on the scale of those in Newport, Rhode Island) soon began to spring up in the western part of town. The area faced Mount Ascutney, and "looked out upon a scene" that artist John Elliott likened to the Val d'Arno—the valley of the Arno near Florence, Italy.

The Colony member most responsible for the design of the new houses was Charles A. Platt, an architect whom Frank Lloyd Wright called "a very dangerous man—he did the wrong thing so well." From Wright's viewpoint, the strong Italian influence in Platt's domestic architecture and the formality of his garden design is what made Platt dangerous. But these were precisely the characteristics that the more affluent Colonists cherished.

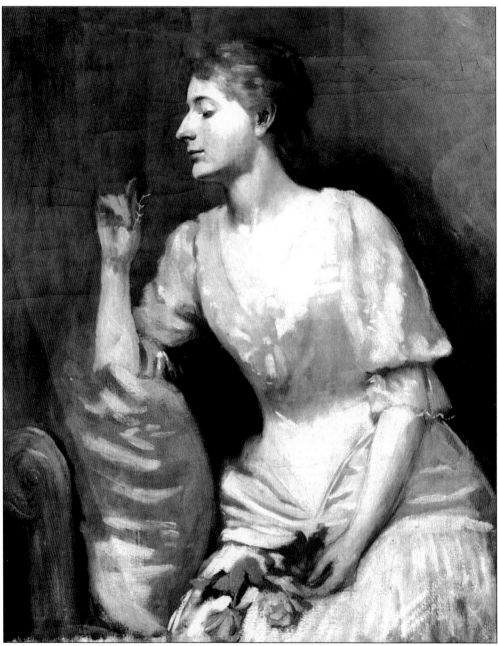

Whether their home was grand or simple, Ralph Waldo Emerson's adage that "the ornament of a house is the friends who frequent it" was the Colonists' byword. This simple portrait of a woman holding two pink roses served to ornament the home of her friend William Howard Hart, to whom this painting is attributed. The sculptor Frances Grimes provides us with a good feeling for the interaction of the grand and the simple in the Colony: "What was seen in the sense, the pictorial sense, was so important. Gowns that were praised there would not have been praised on Fifth Avenue. They were gowns that a painter would like to paint. This point of view perhaps explains why so many of the women in Cornish had unusual beauty, for I am as sure they had unusual beauty as I am sure the men were witty." (Courtesy Nyboer family.)

This simple Congregationalist church, which was attended by President Wilson and his family, was built in 1841, though town historian William Child noted that many of the "friends who frequent[ed] it disagreed about its location." The members of the congregation finally settled on the church's present site in Cornish Center. On one occasion, while driving to church in their fancy Pierce-Arrow, the presidential family met up with the minister, Dr. Fitch, in his horse and buggy. Wilson remained discreetly behind the minister until they reached this church. (Courtesy CHS.)

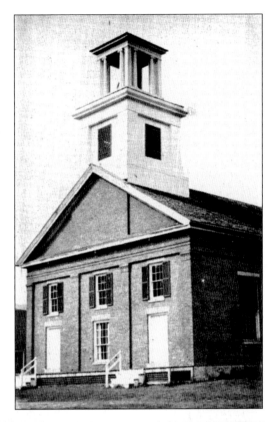

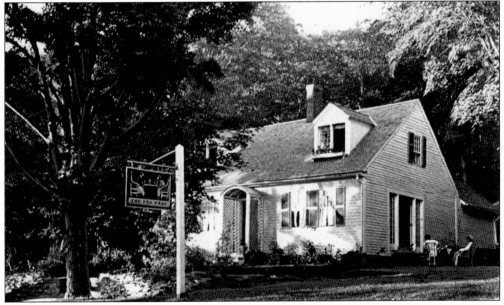

The Tea Tray was a popular place for Colonists to convene for afternoon tea. It was especially favored by Pres. Woodrow Wilson and his family during their summer stays in Cornish. The handsome double-sided sign, seen in the foreground, was designed by Maxfield Parrish. One of his favorite models, a Plainfield woman named Sue Lewin, posed for it. (Courtesy CHS.)

City folk organized the Mothers' and Daughters' Club in 1911. The club announced in a local newspaper that it was "for the women of the community—to draw them out of their circumscribed home life, to make them better acquainted with the women of the 'city colony,' and to help them in every way possible." A weaving and rug-making industry was established to sustain the group and provide extra income for its members. (Courtesy CHS.)

People on their way to any event at the Plainfield Town Hall would have passed by these buildings. In this photograph, taken about 1900, the second building on the left is the Blow-Me-Down Grange, where Lucia Fuller's 1893 mural, *The Women of Plymouth*, still decorates the stage. On the left, several residents have gathered on Main Street, near the Mothers' and Daughters' Club. (Courtesy PHS.)

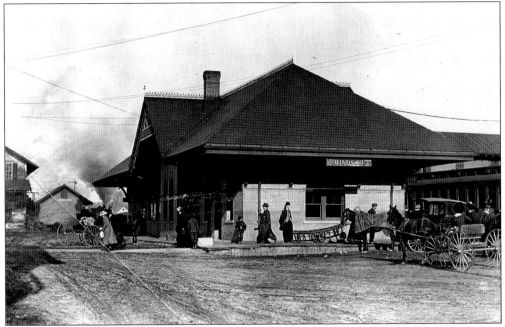

A steam engine belches smoke as it slowly approaches the Windsor Depot in 1900. After a long, grimy, uncomfortable journey (most likely from New York City), passengers from this train bound for Plainfield or Cornish will be transported from the station by horse and carriage across the Cornish-Windsor Covered Bridge. The bridge is the longest two-span covered bridge in the world and the longest wooden bridge in the United States. (Courtesy WHS.)

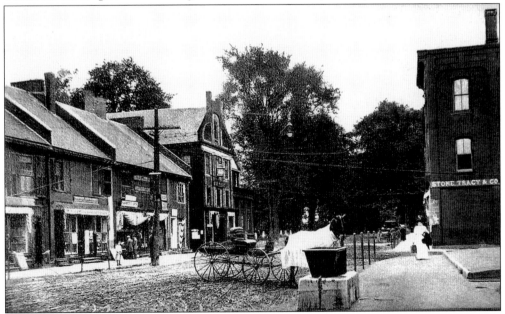

In this *c.* 1905 view of Main Street, looking toward Windsor House, two men window-shop at Henry Vondell's boot, shoe, and harness shop, while a small girl (near Jones Restaurant) observes a passenger who has arrived at the Windsor Depot. No doubt they are all wondering why the horse is wearing a blanket on such a fine summer day. (Courtesy SGNHS.)

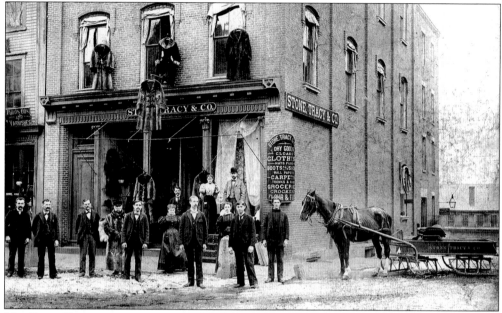

The Stone Tracy store was conveniently located on a corner near the Windsor Depot. A fire destroyed the block in 1897, but Mrs. Dwight Tuxbury rebuilt the store in the following year. The store's general merchandise included groceries, clothing, shoes, carpets, and dry goods. The horse-drawn sled in this view indicates that the store made home deliveries. No doubt the establishment was well patronized by the Colonists. (Courtesy WHS.)

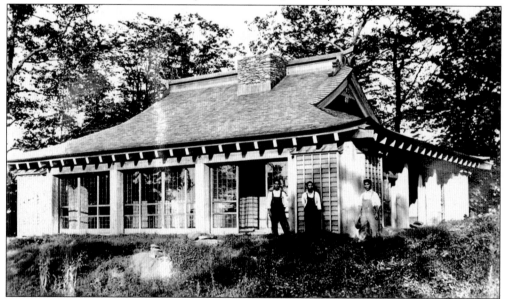

Moving on to the slightly larger places, seen here are Japanese workers as they pause during construction of the most unusual of all Colony homes: the Glass House belonging to Robert and Katherine Barrett. Robert, a founding member of the Association of American Geographers, combined his extensive travels throughout Asia, the Himalayas, and Patagonia with his commitment to geology. He and his wife were philanthropists who supported many local educational projects. (Courtesy CHS.)

With an emphasis on simplicity, here the Barretts enjoy a meal in the Japanese style. Guests of the Barretts often were given sandals to wear, asked to sit on the floor, and served their food from wooden plates. Robert originally hired Katherine, "a tall thin angular woman," to be the librarian of Cornish's Stowell Free Library. He then fell in love with her, and they married after a whirlwind romance. (Courtesy SGNHS.)

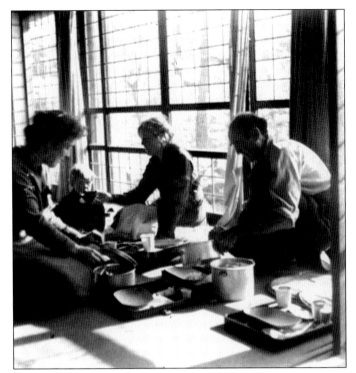

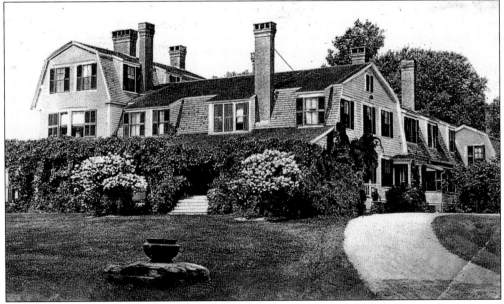

The next few images depict houses of a grander scale, but Ralph Waldo Emerson's notion of "friends" as "ornament" is still applicable to each home. Pictured here is the house of Charles C. Beaman, the man who persuaded Augustus Saint-Gaudens, the first Colonist, to settle in Cornish. In 1874 Beaman married Hettie Evarts of Windsor, Vermont, and soon acquired land that he rented or sold to his artistic friends from New York. (Courtesy CHS.)

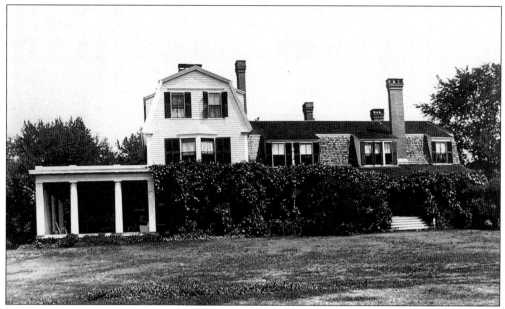

Charles Beaman named his country estate Blow-Me-Down, after a brook that flowed nearby. The diaries of Beaman, Stephen Parrish, and Laura Walker prove that Hettie and Charles were generous hosts and that their home was often the center of social activity. Saturday night suppers were followed by dancing, bowling, and billiards in the "casino," whose floor had sparkling coins embedded in it. (Courtesy CHS.)

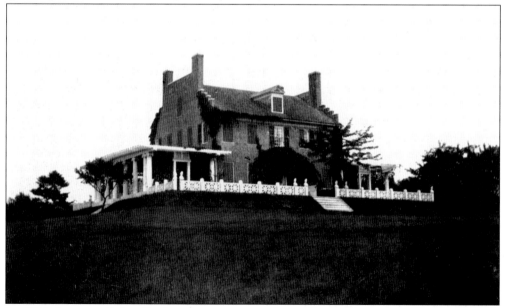

In 1885 Augustus Saint-Gaudens began to rent from Charles Beaman a dilapidated brick house in Cornish that was known locally as the former Huggins Folly inn, but which some wags referred to as "Blow-Me-Up." Eventually, in 1891, Saint-Gaudens purchased the property, for the price of $500 and a bas-relief of Charles Coatesworth Beaman, a piece the sculptor executed in 1894. Saint-Gaudens gradually fixed up the home, which he named Aspet. (Courtesy SGNHS.)

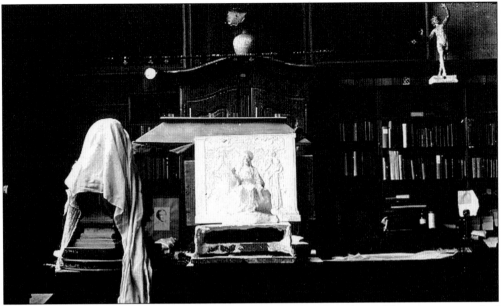

In July 1900, Saint-Gaudens set up his studios in Cornish, where he and his assistants worked in this building, known as the Little Studio. At Aspet, Saint-Gaudens and company completed the *Sherman Monument*, a work that was begun in a field in 1901, gilded in 1902, and unveiled in 1903 in New York. The following year, when this picture was taken, Saint-Gaudens's *Robert Louis Stevenson Memorial* was unveiled in Edinburgh, Scotland. (Courtesy SGNHS.)

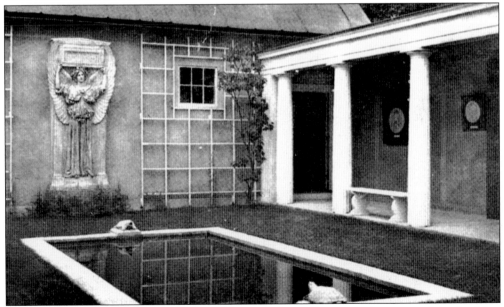

Here the *Amor Caritas* by Saint-Gaudens embellishes a Roman-style courtyard in the New Studio. A woman named Davida Johnson Clark was the model for this piece, as well as for the *Diana* (the famous nude statue that once graced the Madison Square Garden Tower as a weathervane), and for the figure of Victory in the *Sherman Monument*. Clark frequently modeled for Saint-Gaudens, became his mistress, and gave birth to their son Louis, who was named for Augustus's brother. (Courtesy CHS.)

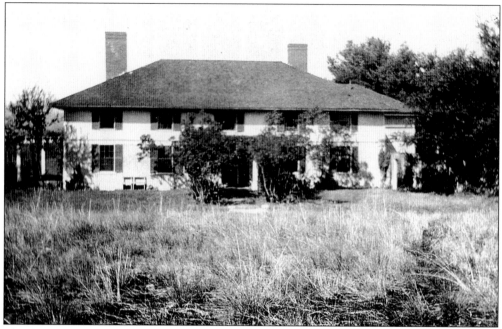

The first city folk (or "them darn critters") to build a home in Cornish were Henry and Laura Walker. It was the first commission for their friend Charles A. Platt, initiating, in 1899, a series of local houses designed by Platt. Originally a single-story bungalow for summer use, the Walkers later renovated the house. There was a small barn for a cow, which occasionally appeared grazing in Platt's cornfield. (Courtesy Smith family.)

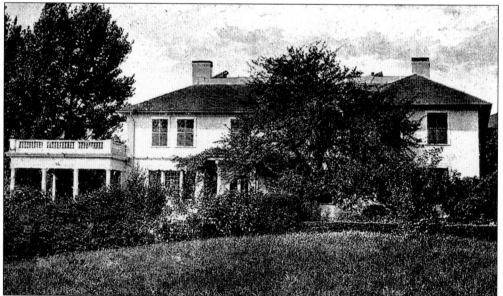

In 1890 Platt, who had yet to commit himself fully to a career in architecture, built his own Cornish house. Also beginning as a summer place, it was enlarged and altered several times. Nevertheless, the design remained simple, especially when compared to some other nearby houses Platt designed. The garden at Platt's home was grand, and true to the principles in his book *Italian Gardens*, it incorporated the landscape as outdoor living space. (Courtesy CHS.)

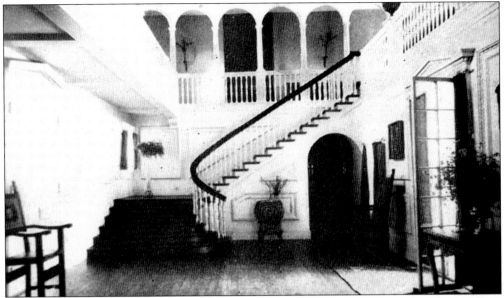

This is the entrance hall of High Court, a three-sided Italian Renaissance villa centered on a colonnaded loggia courtyard. Platt designed the home for Annie Lazarus, the socialite younger sister of Emma Lazarus, the poet of "The New Colossus," whose closing lines are engraved on the Statue of Liberty. After fire destroyed the original High Court building in 1895, an almost identical structure was soon built in its place. (Courtesy CHS.)

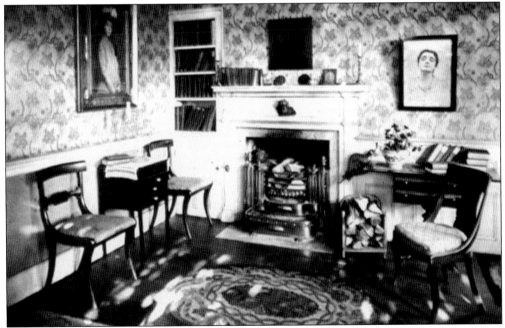

This interior view of Poins House, an old brick tavern in Plainfield, has its share of paintings, probably largely by Colony artists. It was the home of playwright Louis Evan Shipman and wife Ellen Shipman, an important landscape architect. So that no one would be in the dark, on one of her calling cards Ellen Shipman wrote that she was "geographically in Plainfield, socially in Cornish." (Courtesy SGNHS.)

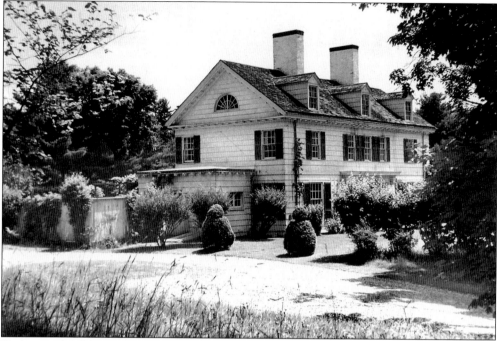

Herbert and Adeline Adams spent 40 summers in this Plainfield home, which was designed by Charles Platt in 1903 and later became known as the Hermitage. Surrounded by hedges and gardens, and with a commanding view of Mount Ascutney, the estate was also enjoyed by many visitors. Platt and Herbert Adams collaborated on World War I memorials for Fitchburg and Winchester, Massachusetts, and also worked together on the *McMillan Memorial Fountain* in Washington, D.C. (Courtesy Nyboer family.)

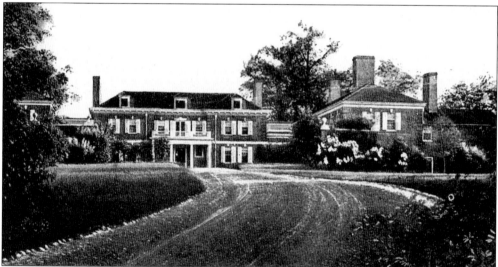

The Winston Churchill estate (pictured) is on a larger scale than the Adams home. Platt worked on the Churchill design over three years, finishing the plans in 1904. Because Churchill's 1899 novel *Richard Carvel* sold almost a million copies and featured a hero who was a naval officer from a prominent Maryland family during the Revolutionary War, Platt's design may have sought to recall an 18th-century mansion. (Courtesy CHS.)

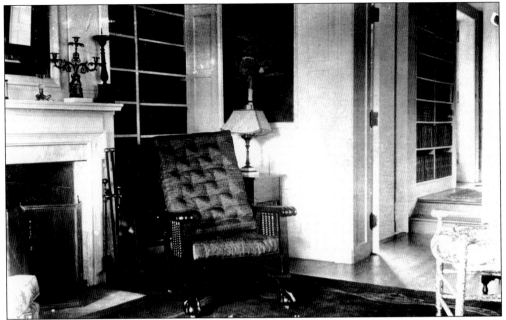

This is the morning room at Winston and Mabel Churchill's estate, Harlakenden. Because this room was accompanied by a huge music room and a drawing room, the home was clearly designed to be more than merely a summer cottage. Just as he did at High Court, Charles Platt followed a U-shaped design. Unfortunately, Harlakenden burned to the ground on October 6, 1923. (Courtesy SGNHS.)

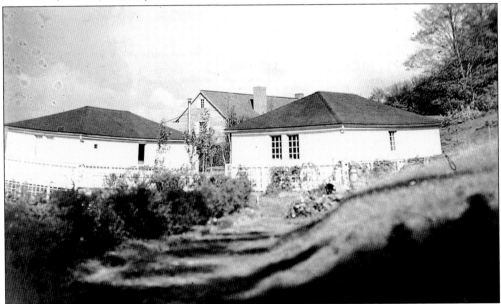

Stephen Parrish was Charles Platt's close friend and neighbor, from whom Platt first learned etching. However, Parrish chose Wilson Eyre, an architect from his hometown of Philadelphia, Pennsylvania, to design his house. Here, Parrish's home, called Northcôte, can be seen in the background at center; on the left is Stephen's studio, and on the right is the studio where his cousin Anne Parrish sculpted. (Courtesy Dartmouth College Library.)

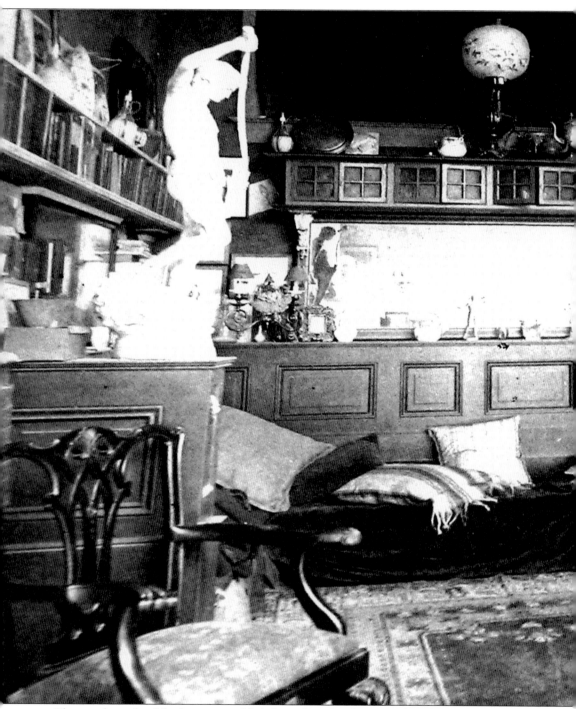

The panels used at Northcôte resembled those from Stephen Parrish's Philadelphia house, and according to his son, may have actually been moved from there to Cornish. Construction of Northcôte began in 1893, but Parrish did not have a studio built until 1902; before that he was busy planning and making his extensive garden, greenhouse, and stable for Betty, his horse. After switching from etching to painting, Stephen Parrish chose many local scenes as subjects for his

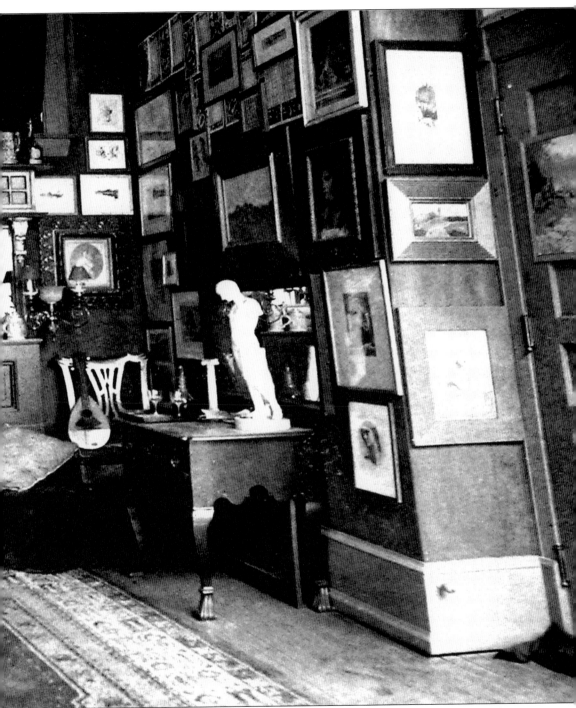

oils. Furthermore, as his grandson Maxfield Parrish Jr. pointed out, "the best sales" for those paintings were "from off his easel in Cornish, N.H." and, by 1920, Stephen had almost completely given up sending pictures to exhibitions or galleries. It was customary, too, for Cornish artists to exchange their works with friends at social occasions. We can't help but wonder how many Cornish artists are hanging on this wall at Northcôte. (Courtesy Dartmouth College Library.)

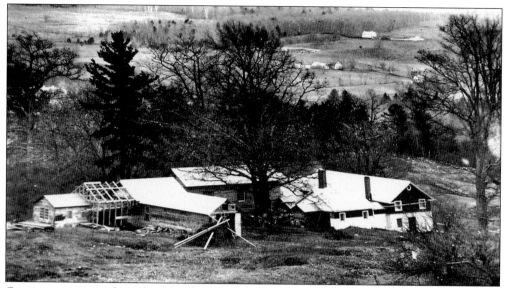

One sunny summer day, when Maxfield Parrish (or Fred, as he was known to family members) was visiting his father at Northcôte, he observed an oak grove across the meadow in Plainfield. He walked over to the grove, took one look to the south and west, and "fell in love with the spot." Maxfield acquired those oaks, plus 19 acres, and began the construction seen above. Northcôte is also visible in the distance. (Courtesy Dartmouth College Library.)

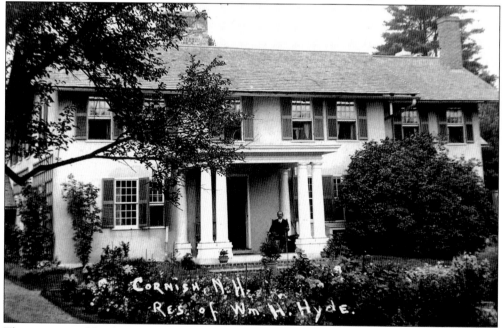

The portrait and landscape painter William Henry Hyde (seated on porch) acquired this home in 1906 from Thomas and Maria Dewing, both significant artists. Thomas, the second Colony "settler," left the area in a huff because he thought it was becoming too social. Because Maria was such an excellent floral painter, the Dewings are said to have introduced gardening to the Colony. After purchasing the property, Hyde extended the gardens at the home, called Doveridge, to make them among the Colony's loveliest. (Courtesy CHS.)

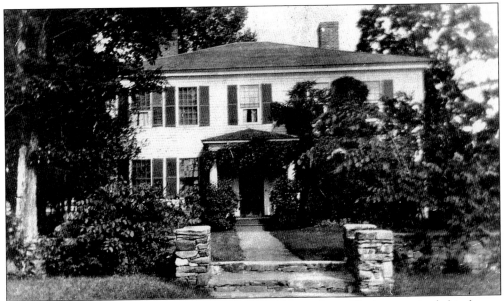

William Henry Hyde's wife was Clarissa Davidge's sister. Once Clarissa acquired this former Kingsbury Tavern (built in 1802) and remodeled it, she became Plainfield's "largest taxpayer." The flippant Mabel Dodge Luhan described Clarissa as "animated, eccentric, rattle-brained," someone who "collected old furniture and promising painters." Among those painters were Marguerite and William Zorach, and Henry Fitch Taylor, whom she married. All three often painted in the Cubist style, which was quite unlike most other Colonists' art. (Courtesy CHS.)

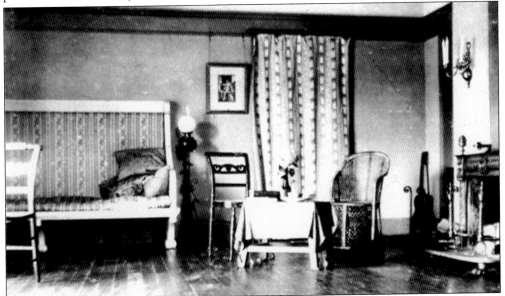

This view of the living room at Monarda, the home of Kenyon and Louise Cox, shows that the couple did not live as opulently as many other Colonists did. Monarda was on the Cornish-Plainfield line, and Kenyon's studio was near the Blow-Me-Down covered bridge. The studio had a huge door so that Kenyon's large murals could be removed and transported. In addition to painting children, Louise Cox was a wood carver, as were fellow Colonists Emily Slade and Rose Nichols. (Courtesy SGNHS.)

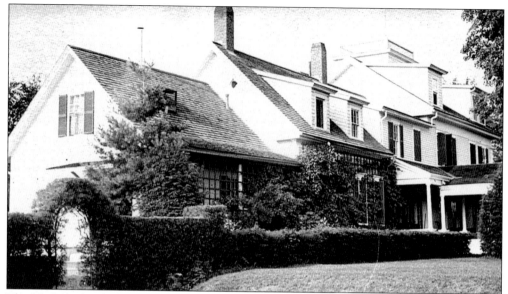

The Nichols family home, Mastlands (pictured), was so named because the land had once produced tall pines that were used for masts on English naval vessels in the 17th and 18th centuries. This view from the southwest corner shows (on the right) the wall for Rose Nichols's garden, which Frances Duncan, a gardening editor, called "a lovable place where one [was] inclined to lounge or read in undisturbed peace." (Courtesy Nichols House Museum, Boston.)

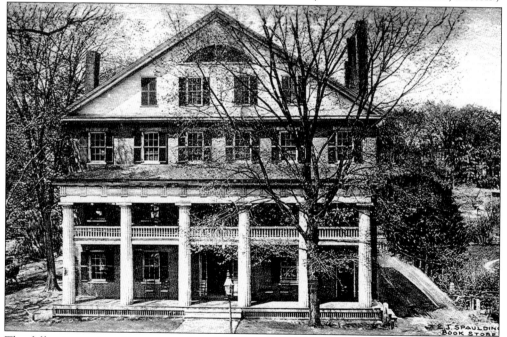

The following series of images are from Windsor, Vermont. Seen here is the Windsor House. Soon after it opened in 1840, the Windsor House acquired the reputation as a superior public house and consequently attracted many prominent guests. Doubtless many Colonists and their visitors stayed at the Windsor House and sampled its gourmet fare because of the inn's convenient location near the Windsor Depot. (Courtesy WHS.)

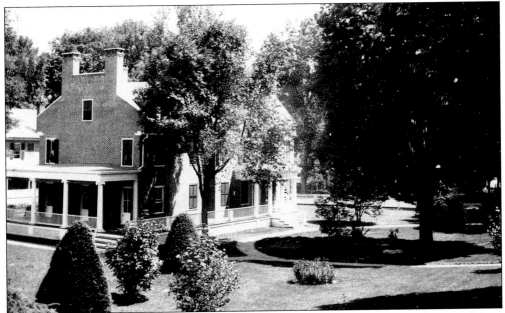

Originally built around 1838, this is the home of Maxwell and Louise Perkins, as viewed from Runnemede, the home of Maxwell's maternal grandfather, William Maxwell Evarts. Evarts had acquired six houses along Main Street in Windsor, rented them to mill workers, and, in the summertime, used them as accommodations for large family reunions—there were 12 children in the Evarts family. (Courtesy WHS.)

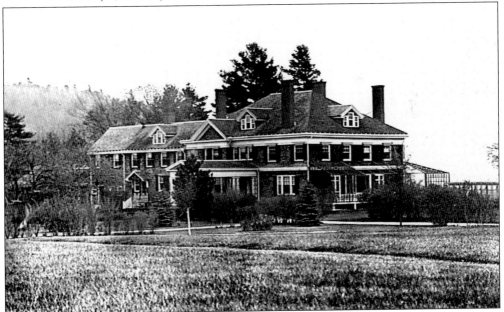

Buena Vista was the home of Francis Kennedy, who was known as "the cracker man" because he manufactured biscuits and then sold his Boston company to Nabisco. The Kennedy family was active in community affairs, was included on Colonists' guestlists, and hosted gala balls. The Kennedys' daughter had the role of Fame in the 1905 celebration for Augustus Saint-Gaudens, *A Masque of "Ours": The Gods and the Golden Bowl*. (Courtesy WHS.)

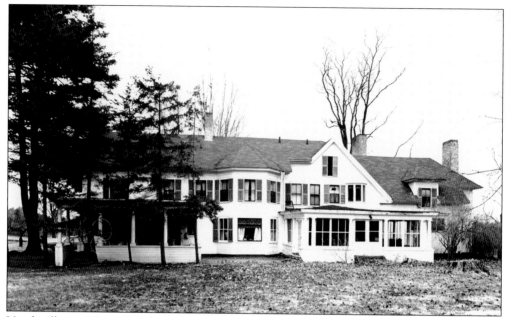

Vaudeville star Marie Dressler quipped, "Fate cast me to play the role of the ugly duckling with no promise of swanning." She owned Pine Tops (pictured) from about 1910 to 1918. Dressler had little spare time for country life because of her roles in early silent films and later in talkies. She is remembered for her films with Mack Sennett and Charlie Chaplin, and starred with Wallace Beery in *Tugboat Annie*. (Courtesy WHS.)

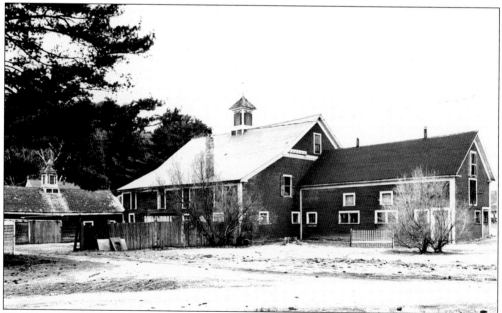

With her manager James Dalton, Marie Dressler operated Windsor Farms, whose barns, at the north end of Windsor, are pictured here. It was an unsuccessful venture; the farm's creditors were numerous. Until recently these barns belonged to the Vermont Highway Department. Since Dressler titled her autobiography *The Life Story of an Ugly Duckling*, it is clear that, although she left Windsor under a shadow, she kept her sense of humor. (Courtesy WHS.)

Five

COLONY ACTIVITIES

CREATIVE PASTIMES

Gone are the days of the calling card. But Cornish Colony members used them with finesse and awareness of their subtleties. Ellen Shipman and Percy MacKaye hastily reminded their friends that although their houses were in Plainfield, their social addresses were in Cornish.

An unwritten rule, however, decreed that no card could appear before 4:00 p.m. The Colonists were in the country to create, to work; the time to play was late in the day. When they did play, though, their activities were often executed with great sophistication.

Two famous masques in Cornish were widely reported in newspapers throughout America. The first, held in 1905, celebrated the 20th anniversary of the presence of the Saint-Gaudenses in Cornish. For that masque, more than 70 participants—Colony members and local residents—turned to a type of Medieval and Renaissance allegorical entertainment with elements of poetry and music, plus elaborate costumes, scenery, and props. Later, in 1913, Percy MacKaye wrote *Sanctuary: A Bird Masque*, to alert people about the possible extinction of some birds because their plumage was used to decorate women's hats. Because Cornish was the seat of the "summer White House" in 1913, 1914, and 1915, the audience on opening night included Pres. Woodrow Wilson and his wife, who were there to watch their daughters' performance in the masque.

This love of pageantry and penchant for theatrical charades eventually led to construction of a stage in the Plainfield Town Hall. Maxfield Parrish's design was used to create the stage's backdrop in 1916, and it can still be seen by visitors today.

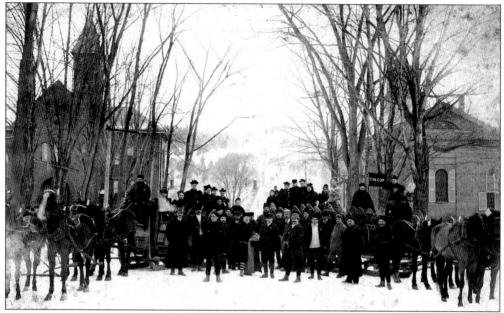

For all their intense activity as creative artists, the Colonists did heed the words of Herodotus: "If a man insisted always on being serious, and never allowed himself a bit of fun and relaxation, he would go mad or become unstable without knowing it." In this photograph, note that all age groups are represented in Windsor's Tin Cup snowshoe club; no doubt many were "sewed in" to their long underwear for the season. (Courtesy WHS.)

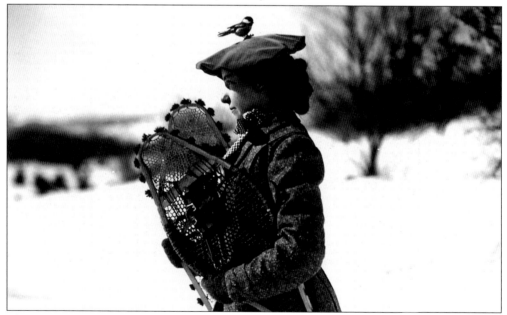

Those who remained in Cornish all winter long did affectionately and proudly call themselves "Chickadees." Louise Baynes, here doubly a "Chickadee," seems quite content to be out on a sunny winter day, navigating through the snow to enjoy the company of her "wild bird guests" (the title of one of her husband's books). Louise also seems to be following the words of the book's subtitle: "how to entertain them." (Courtesy CHS.)

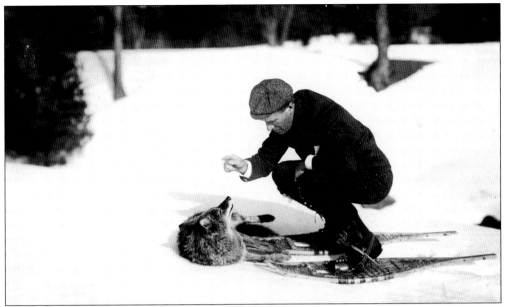

Ernest Harold Baynes resolutely and patiently trained and then photographed the many wild animals that inhabited the Blue Mountain Forest. In 1924 he published *Sprite, the Story of a Red Fox*, one of the many books he wrote describing his experiences. The books are not exclusively directed to children. This picture shows Baynes breaking some sad news to Sprite, along with the caption: "I told him we must part." (Courtesy PHS.)

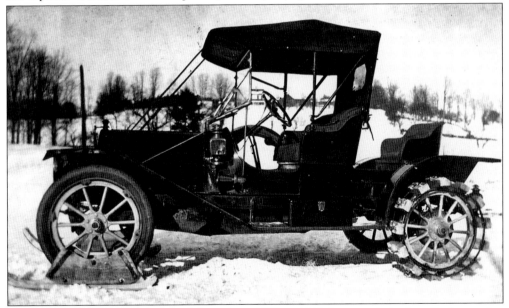

In the journals that Stephen Parrish kept from 1893 to 1911, he sometimes described motoring excursions with his son Fred (better known as Maxfield), who was one of the first Colonists to purchase a "horseless carriage." Winter sleighing conditions seemed to be a major concern of Stephen's, but once automobiles replaced horses and sleighs for winter transportation, "Chickadees" must have been obliged to attach chains and skis to the vehicles. (Courtesy Dartmouth College Library.)

Augustus Saint-Gaudens understood the need for winter activity; he reveled in outdoor pursuits such as hockey and tobogganing. At Aspet he constructed two impressive toboggan runs (pictured) that resembled the scaffolding built for work on his massive sculptures. His son Homer, and his friends, must have enjoyed many exciting rides! (This image also shows the Studio of Caryatids under construction.) (Courtesy SGNHS.)

Here we see members of the MacKaye and Baynes families, who were close friends, enjoying some fun and relaxation in springtime. An inscription on the photograph indicates the group saw a white-tailed deer that day. Might it have been related to "Actaeon, the Story of a White-Tailed Deer," part of Baynes's posthumously published My Wild Animal Guests (1930)? (Courtesy MacKaye/Ober family.)

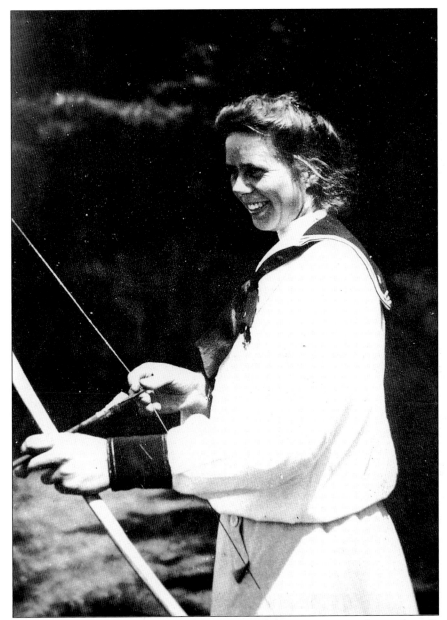

At first Margaret Nichols did not enjoy life in Cornish because it was a far cry from Boston's stimulating culture. However, she and her sister Rose appreciated having a place to entertain their city friends, several of whom adopted Mastlands as their summer retreat. With its sprawling 150 acres, the estate provided ample space for Margaret to practice archery. The family tennis court was also a definite lure. In fact, tennis may have even taken precedence over archery for Margaret. She said: "In 1892, when we moved to Cornish, tennis was still in its infancy . . . Rose and Marian . . . arranged for us to have a court; that is, we picked out a level area and kept the grass short. After a few years of suffering from the completely unpredictable bounces from the rough grass I pleaded for and obtained a clay court. The new court, following the usual practice in Cornish of featuring charming accommodations for the onlookers, was placed to the east of a large spreading pine." (Courtesy CHS.)

One fine midsummer day, around 1915, Maxfield Parrish took time away from his easel to teach his four children a lesson in marksmanship at The Oaks. The children are, from left to right, John Dillwyn, Jean, Stephen (partially hidden), and Maxfield Jr. They seem quite fascinated with Maxfield's demonstration of the proper use of a 22-caliber rifle. Their education in other subjects was carried out by local Plainfield residents: Lucy Ruggles Bishop worked with their general education, and Marguerite Lewin Quimby was their music teacher. As many children are prone to do, Max Jr. often illustrated the margins of his papers. (Courtesy Dartmouth College Library.)

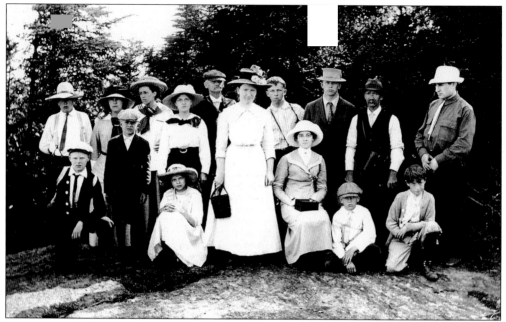

Hiking was an outdoor activity best done during the summer. Cornish Flat mill owner A. P. Butman noted on the back of this photograph that he received it from F. J. Franklyn, who took the picture on June 16, 1913, from the top of Croydon Mountain in Corbin's Blue Mountain Forest. It is hard to imagine anyone today climbing a mountain dressed as elaborately as these people are. (Courtesy CHS.)

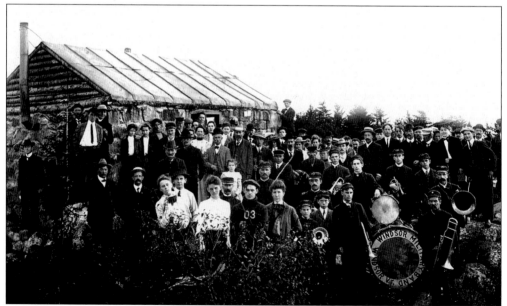

Mount Ascutney, which is over 3,300 feet high, of course presented the greatest challenge to local summer hikers. This large group had their feat recorded with this photograph. The presence of the Windsor Military Band suggests that these hardy people, who included Rev. Parker Manzer at far left, may have made the climb in order to dedicate the Summit House on Labor Day 1904. (Courtesy WHS.)

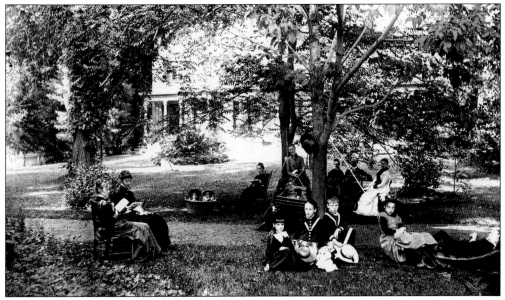

This photograph was taken around 1890. On a fine, lazy summer's day, the family of Eastman Lamson clearly relish relaxing under the shady trees on the grounds of their homestead in Windsor. Lamson was one of the founders of Jones, Lamson Machine Company, a cotton mill. (Courtesy WHS.)

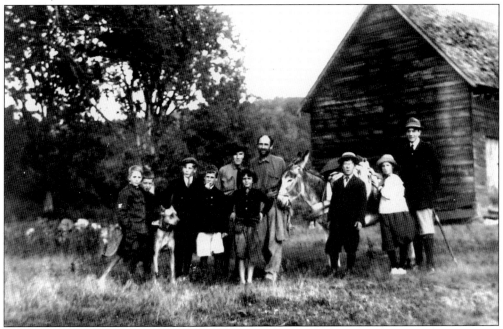

Gathered for a picnic are, from left to right, two unidentified young boys; a dog; an unidentified young boy; Robin MacKaye; Ernest Harold Baynes; Morse Barnard, son of sculptor George Barnard; Robert Barrett; a donkey; an unidentified young boy; Arvia MacKaye; and Percy MacKaye. George Barnard took over Saint-Gaudens's modeling class at the Art Students League. Barrett was a likable eccentric, who built and resided in the Glass House, and appeared around town barefoot and barelegged. (Courtesy Dartmouth College Library.)

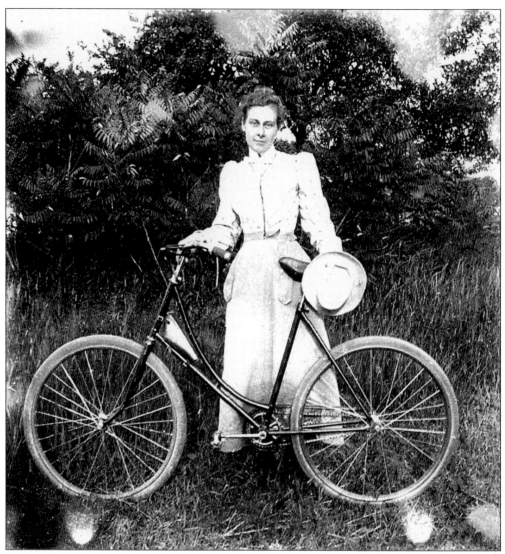

This unidentified Cornish woman seems to want to be remembered for having a bicycle and being dressed in the proper attire, which was a challenge for women. Maria Oakey Dewing reportedly solved one problem by looping her skirt over the handlebars—a risky solution. She occasionally fell off the bike (because her view was blocked), and arrived late at social functions. Louise Cox learned to ride by walking her bike over to a neighbor's house, soliciting help, and placing a soapbox on the ground to facilitate mounting the bike. This method, however, depended upon the generosity of her friends, who would, presumably, have to run along with her in case she fell. Eleanor Platt, the story goes, once rode over a leaning fence and fell head over heels into a meadow. Men were no less vulnerable. This particular pastime, with the potential for spills, was hazardous for them too. Kenyon Cox, for example, landed in the Walkers' hollyhocks. And Henry Walker took a spill into some bushes alongside of a path and ended up pinned under his bicycle on one occasion. (Courtesy CHS.)

Among Colony members, golf had its share of fanatics. Arthur Whiting wrote to his music publisher, Gustave Schirmer, in June 1895: "I hear you have . . . played your first game of golf. We have . . . a fine course and are deep in 'lofting' and 'putting.' Be sure to bring your clubs." Whiting later wrote, "Bring your golf tools and we will till the soil on Kennedy's links together." This photograph provides a view of the Kennedy family's golf course. (Courtesy WHS.)

Frank Kennedy, on the far right, looks at the photographer. The Beamans also installed a golf course on their property, so there were ample fairways on which to hone one's skills. But, as the pianist Arthur Whiting warned, "You may well be surprised that my golf score remains at 81 but . . . I find that sport lames my left wrist and so have to look on disconsolately while others wield the club." (Courtesy WHS.)

Tennis had its partisans. This view of artist Henry Prellwitz's studio reveals some interesting items, including two tennis rackets. Whose are they? Lucia and Henry Fuller had a tennis court, but during the summer of 1906 they were staying at the Prellwitz's house while Ethel Barrymore rented their place. That summer, interest in tennis peaked—especially among the male population. Percy MacKaye's poet friend William Vaughn Moody wrote that Barrymore had "a tennis court and a great cement-lined bathing pool, both of which we indulge in early every day, and the combination, with a highball and a cigarette afterwards on the big stone-flagged porch, is difficult to beat." Moody further noted that Ethel "install[ed] herself across the road, painting, polishing, and upholstering with her own fair hands and those of the volunteer corps, of which I am a humble but most efficient member." (Courtesy SGNHS.)

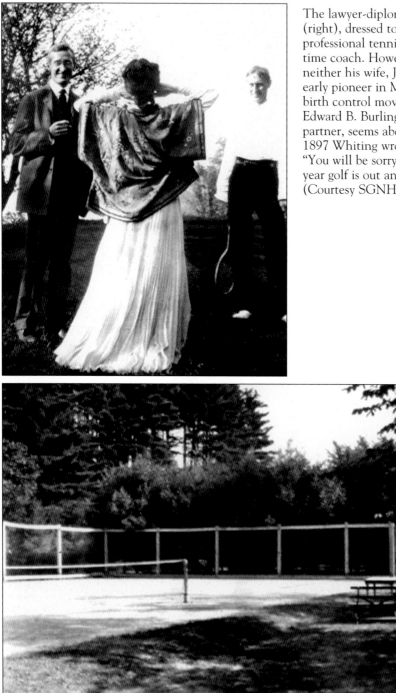

The lawyer-diplomat George Rublee (right), dressed to play, hired a professional tennis player as full-time coach. However, it appears neither his wife, Juliet (center), an early pioneer in Margaret Sanger's birth control movement, nor Edward B. Burling, George's law partner, seems about to join him. In 1897 Whiting wrote to Schirmer, "You will be sorry to hear that this year golf is out and tennis is in." (Courtesy SGNHS.)

At one time there were 16 tennis courts in Cornish—at the Beaman, Houston, and Nichols homes, and elsewhere. Playwright Louis Evan Shipman and wife Ellen Shipman, a landscape architect, had the foresight to construct their court at Brook Place on a north/south axis so that players and onlookers were shielded from the sun. Rose Nichols's court was not so carefully laid out and hence was a less popular haunt for tennis enthusiasts. (Courtesy SGNHS.)

William Vaughn Moody's description of this pool reminds us of the zest with which Colony members attended the pool parties Ethel Barrymore regularly hosted. In one of his letters, Moody commented: "[Ethel's] premises include a marble swimming pool, under a vine-covered pergola, with Greek pillars from which she is said to rejoice to dive. Bathing suits are furnished by rotation pegs, and the fit shall be as God wills." (Courtesy SGNHS.)

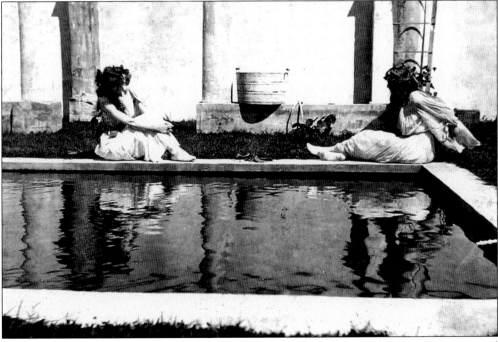

These bathing beauties study their reflection in the Fullers' pool. Dressed in Grecian gowns and garland headdresses of leaves, they strike an artful pose, one perhaps learned from Isadora Duncan, a friend of Juliet Rublee and visitor to Cornish on several occasions. The woman on the right appears to be Lucia Fuller. Perhaps the ladies are dressed in their costumes for the Saint-Gaudens *Golden Bowl* masque. (Courtesy SGNHS.)

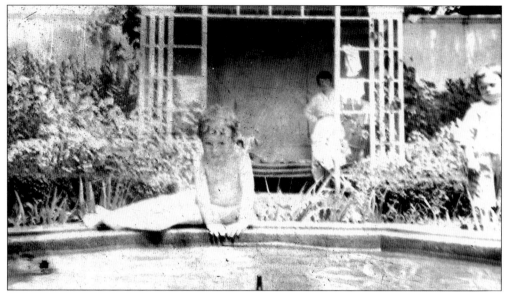

Mabel Churchill (center background) supervises her children at Harlakenden. Too young to swim in the Fullers' pool, the children seem content with their garden pool, which provides lots of fun on a hot day. Their mother once archly advised an invited guest, who wondered what clothes to bring, "In Cornish we wear our oldest clothes, and when we go to Windsor . . . we wear nothing at all." (Courtesy Dartmouth College Library.)

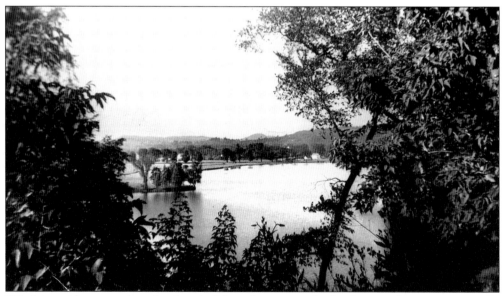

Windsor residents, on the other hand, did not have to go far for their outdoor amusement. In the 1880s the Evarts family constructed an earthen dike to create a pond on their farm in Windsor. The public was permitted to enjoy boating, fishing, and ice skating there. This photograph of Runnemede Pond, as the family named it, was taken from what is today called Paradise Park. (Courtesy WHS.)

The fall season featured special sporting events too. Author Winston Churchill (pictured) liked to hunt and show off his well-trained canine companions, a setter and a pointer. He was keenly interested in outdoor sport and was a member of the Lake Sunapee Fishing Club. Although far from the sea, Lake Sunapee (in central New Hampshire) was for Churchill a pleasant reminder of his days as a cadet at the U.S. Naval Academy. (Courtesy Dartmouth College Library.)

Churchill's dogs—pointer Sailor Ned and setter Big Money—set off in their dog wagon for an adventuresome day with their master. No doubt they anticipated an exciting day ahead, retrieving pheasant or rabbit, perhaps, since their master was also a member of Austin Corbin Jr.'s exclusive hunting club at Corbin's Park (the erstwhile Blue Mountain Forest Association), where Ernest Harold Baynes was a naturalist. (Courtesy Dartmouth College Library.)

Horseback riding during fall foliage season was special. Here, Percy MacKaye (left) and Homer Saint-Gaudens enjoy a ride down to the stone watering trough. When he was a child, Homer was considered by many Colonists to be "difficult but never quite impossible." Naturally he would be proud of taking art history "from the mouths of professionals" and their "art-pregnant language," which Homer later wrote about in his 1943 book, *The American Artist and his Times*. (Courtesy Dartmouth College Library.)

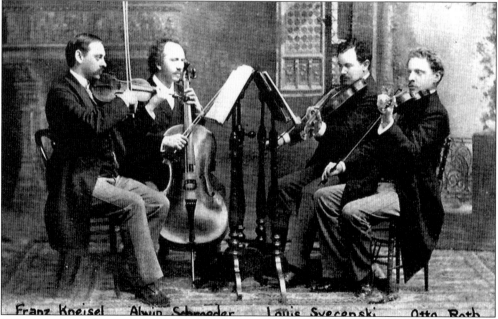

Franz Kneisel Alwin Schroeder Louis Svecenski Otto Roth

Colonists enjoyed many pastimes, other than sport, for fun and relaxation. Their lives were enriched by the talents of members of the Boston Symphony Orchestra: Franz Kneisel, its concert master, and Otto Roth, its principal second violinist. The two men spent several summers entertaining the Colonists. Here Kneisel (far left) poses for a publicity photograph with the Kneisel Quartet, America's first fully professional string quartet. (Courtesy Harvard Musical Association.)

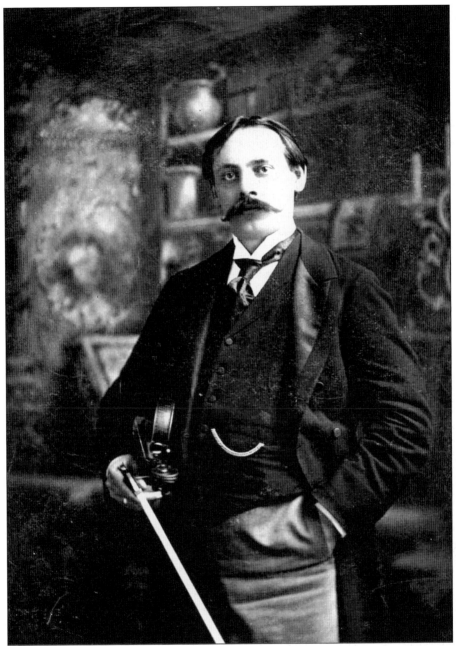

At their frequent performances in Cornish, Kneisel and Roth were often joined by Arthur Whiting as pianist, especially when they played sonatas together. In 1898 the quartet rehearsed in Cornish for its first West Coast tour. Kneisel, pictured here, was not only a fine violinist, but also an exceptional teacher and coach. He later established a summer chamber music camp at his home in Blue Hill, Maine. Kneisel impressed his students with his ability to demonstrate a musical point by playing any of the parts of a string quartet from memory. A taskmaster, Kneisel once explained to a diffident student, "It is better that I tell you now than the newspapers tell you later." There are many Kneisel "disciples" alive today who would reverentially describe him as the "father of American chamber music." (Courtesy Boston Symphony Orchestra.)

Stephen Parrish was particularly fond of music, and his diary gives a valuable account of the numerous musical events and other social occasions that took place in the Colony. The above cartoon appears in his sketchbook, titled *How da do Ned, Harry and Fred*, which he presented as a Christmas gift to his children in 1873. The sketch proves Stephen was an ardent fan of chamber music long before he arrived in the Colony. He passed along his appreciation for music to his son Fred (Maxfield), who hosted musicales in Plainfield at The Oaks. Maxfield's wife, Lydia, was also musically inclined. Because she hated the long New Hampshire winters, she traveled to the South. There, as an ethnomusicologist, Lydia compiled a significant collection, which she published in the book *Slave Songs of the Georgia Sea Islands*. Of her writing, Maxfield wryly commented, "It never occurred to me that she could write." (Courtesy Dartmouth College Library.)

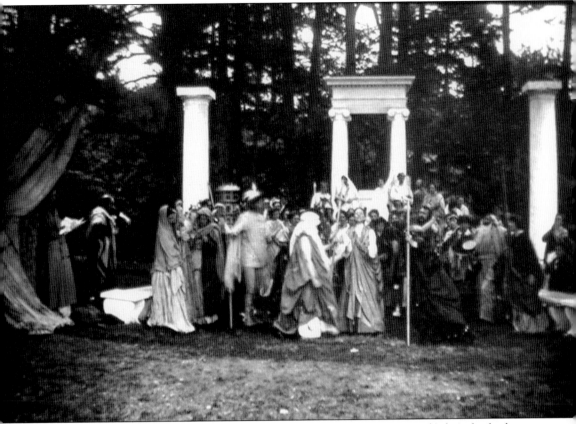

These musicians remind us of the enormous impact pageants and masques had on both the Colony and American culture early in the 20th century. To honor Augustus Saint-Gaudens's 20th anniversary in Cornish, 75 artists and their families participated in an unprecedented event on June 22, 1905: *A Masque of "Ours": The Gods and the Golden Bowl*, America's first pageant, was played before more than 100 guests. As the sun set over Mount Ascutney, the masque concluded with a dramatic burst of pink flame; Minerva (Ellen Shipman) emerged from the smoke and presented Saint-Gaudens with the prize: a golden bowl. A local newspaper account reported, "She "plac[ed] the bowl in the hands of her astonished guest of honor, declaring him to be the worthy successor of Jove." With the cast following, the appointed king and his queen were ushered to a banquet in a chariot. (Courtesy SGNHS.)

With this Greek temple and altar as the set, A *Masque of "Ours"* was performed in a meadow at Aspet. Maxfield Parrish was instrumental in arranging the event; Percy MacKaye wrote the prologue; Louis Evan Shipman penned the script; and Arthur Whiting composed the incidental music. Naturally, beautifully coordinated costumes and intricate props were

created for the masque. Its plot was one of tender grandeur: mythical gods and goddesses, whom mortals harassed, inhabited the Cornish countryside. Needing a king, the mythological figures unanimously agreed that Saint-Gaudens was the only mortal suitable to rule the Cornish realm. (Courtesy SGNHS.)

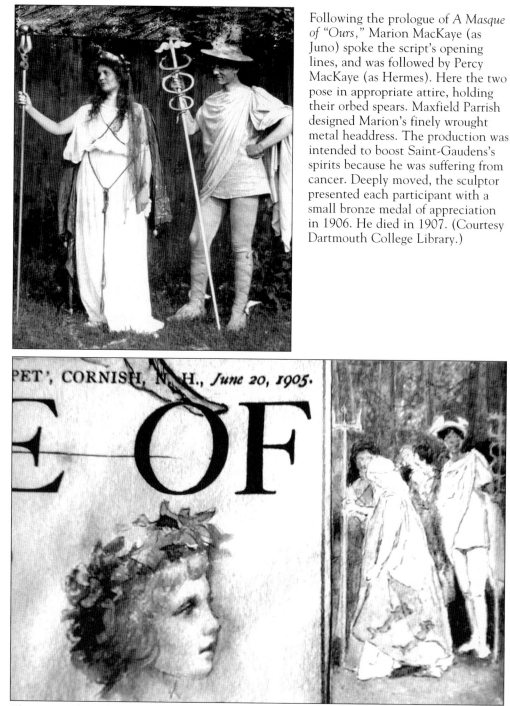

Following the prologue of *A Masque of "Ours,"* Marion MacKaye (as Juno) spoke the script's opening lines, and was followed by Percy MacKaye (as Hermes). Here the two pose in appropriate attire, holding their orbed spears. Maxfield Parrish designed Marion's finely wrought metal headdress. The production was intended to boost Saint-Gaudens's spirits because he was suffering from cancer. Deeply moved, the sculptor presented each participant with a small bronze medal of appreciation in 1906. He died in 1907. (Courtesy Dartmouth College Library.)

This is an enlarged image from the program for *A Masque of "Ours": The Gods and the Golden Bowl*; the pages of the program featured illustrations by several artists in the margins. On the left is a Frances Houston drawing of one of the children, perhaps Arvia MacKaye, dressed for the performance. The illustration on the right, by Stephen Parrish, shows Frances Slade (as Neptune) and Percy MacKaye (as Hermes) ready to deliver a message. (Courtesy MacKaye/Ober family.)

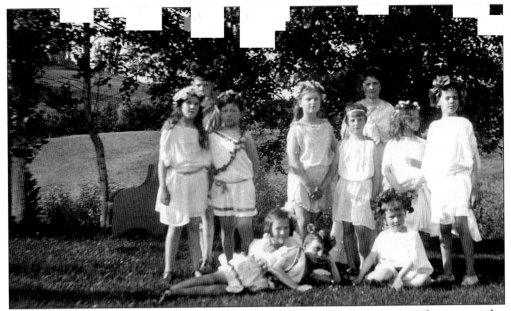

This unidentified goddess and her attendants also played roles as satyrs, fauns, nymphs, bacchantes, and dryads in the masque. As they materialized from their hiding places in the pine ravine, the children were enchanting. They giggled spontaneously as Maxfield Parrish, ever the comedian, brushed them aside. Dressed as Chiron the Centaur, in his splendid and elaborately concocted costume, Parrish clattered off—rolling hooves, hindquarters, and all. (Courtesy Dartmouth College Library.)

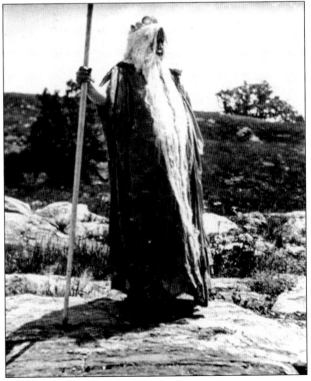

The children wondered how Frances Slade (pictured) could possibly play the male role of Neptune. Marion MacKaye noted that when Frances appeared "with her great masculine stride and enormous voice, long, white beard and hair, she was a hit with her comic masculine ways and voice." Her entrance was accompanied by a loud clap of thunder and she wore a sea-green and blue costume embroidered with fish. (Courtesy SGNHS.)

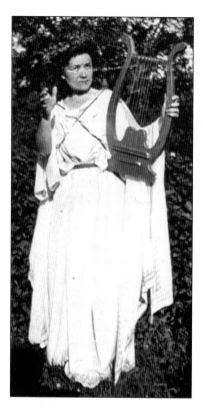

Mrs. E. F. Mann played Erato, the muse of lyric and love poetry. Her costume demonstrated the creativity and attention given to A Masque of "Ours": The Gods and the Golden Bowl. The production set the tone for a trend that captivated the nation—more than 300 pageants were created soon after. Percy MacKaye helped define the artistic standards for such productions and served on the American Pageant Association committee, established in 1913. (Courtesy SGNHS.)

Shortly after the masque performance, the MacKayes were given a beautifully illustrated program, a detail of which is shown here. William Henry Hyde, a painter of portraits and landscapes as well as an illustrator, sketched himself in the role of Leander, a god represented as half lion and half man, while William Howard Hart sketched a staff and grapevine for his role of Silenus, the tutor of Bacchus. (Courtesy MacKaye/Ober family.)

Gradually the masque and pageant movement merged into the taste for community drama. The second pageant produced in the Colony was presented on June 24–25, 1913. The *Pageant of Meriden*, in part written by Percy MacKaye, was commissioned to commemorate the centennial of Meriden's Kimball Union Academy. This is the cover artwork, originally an oil-on-board painting, used on invitations and programs for the event. (Courtesy Kimball Union Academy.)

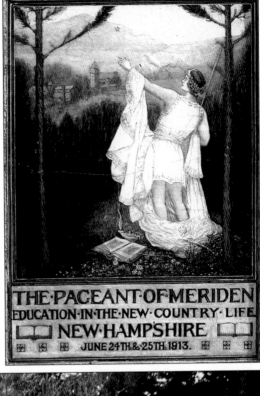

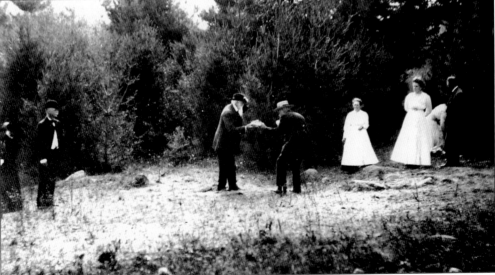

To involve the larger community, the annual Old Home Day celebration was moved up from August to coincide with the June pageant. Mr. Alvah B. Chellis (center left), Kimball Union Academy class of 1861, here presents a cake to John Hall Calif, who at age 94 was the town's oldest resident. Arthur Farwell composed an original score for the pageant, thus setting an example for future community dramas. Farwell conducted a small orchestra on a stage especially constructed for the musicians. (Courtesy Kimball Union Academy.)

PROGRAMME
FOR THE BIRD MASQUE

SANCTUARY

MCMXIII

Locally, 1913 was a significant year for pageantry. On September 12, *Sanctuary: A Bird Masque*, written by Percy MacKaye, was performed at the opening of the Meriden Bird Club, which Ernest Harold Baynes helped to establish. He and MacKaye were calling attention to the indiscriminate use of bird plumage for women's hats. The masque was photographed in color by Arnold Genthe. This program cover was printed from a woodblock design by Kenyon Cox. (Courtesy CHS.)

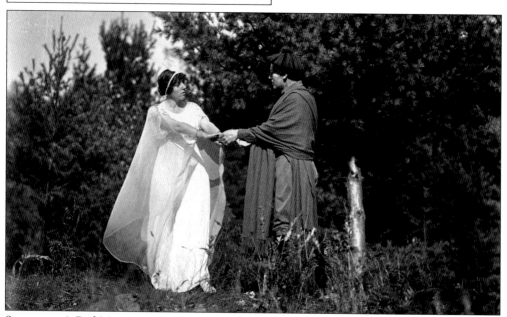

Sanctuary: A Bird Masque was an example of art aiding environmentalism. Along with several Colonists, Pres. Woodrow Wilson's two daughters starred in the production: Margaret Wilson sang "The Hermit Thrush," composed by Frederick Converse, and Eleanor Wilson played Ornis, the Bird Spirit. Here Eleanor greets Ernest Harold Baynes as Alwyn, the Poet. The presence of the presidential entourage—Woodrow, wife Edith, and extra Secret Service agents—drew further attention to the plight of endangered birds. (Courtesy Dartmouth College Library.)

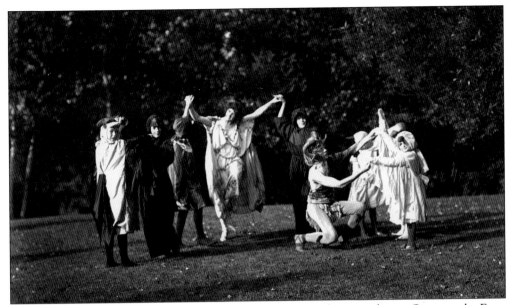

Juliet Rublee, as the dryad Tacita (at center), leads cast members in a dance. Quercus, the Faun (shown kneeling with the children on the right) was played by the masque director, Joseph Linden Smith, who also was the stage producer for Percy MacKaye's *Pageant and Masque of St. Louis*. After its premiere in a woodland setting, *Sanctuary* was performed more than 170 times throughout America, including the dedications of more than 100 bird sanctuaries. (Courtesy Dartmouth College Library.)

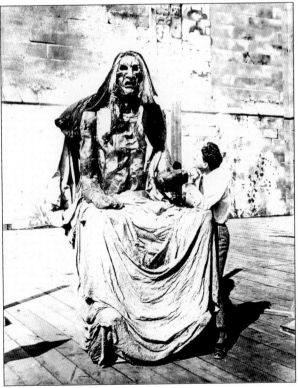

Percy MacKaye's most impressive pageant, *Pageant and Masque of St. Louis*, was presented in 1914. His script became a community drama (a phrase he promoted), which 7,500 people participated in and 500,000 attended, to celebrate the sesquicentennial of the city of St. Louis. A 90,000-square-foot semicircular stage accommodated the cast and equestrians. Here MacKaye scrutinizes the puppet Cahokia, 25 feet tall. (Courtesy Dartmouth College Library.)

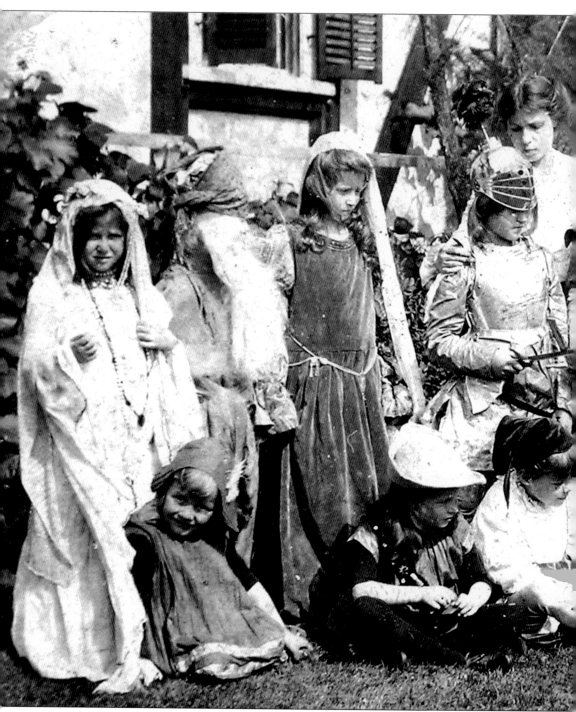

In addition to masques and pageants, the Colonists had other outlets for their interest in drama. Dramatic readings and charades played a prominent role in Colony social life. (Maxfield Parrish even had a stage in his west wing addition, where he starred in his favorite game, charades.) The productions were particularly enjoyed by the children, who also took pleasure in making costumes for *tableaux vivants*. Here, Lucia Fuller stands in the back row, behind her daughter,

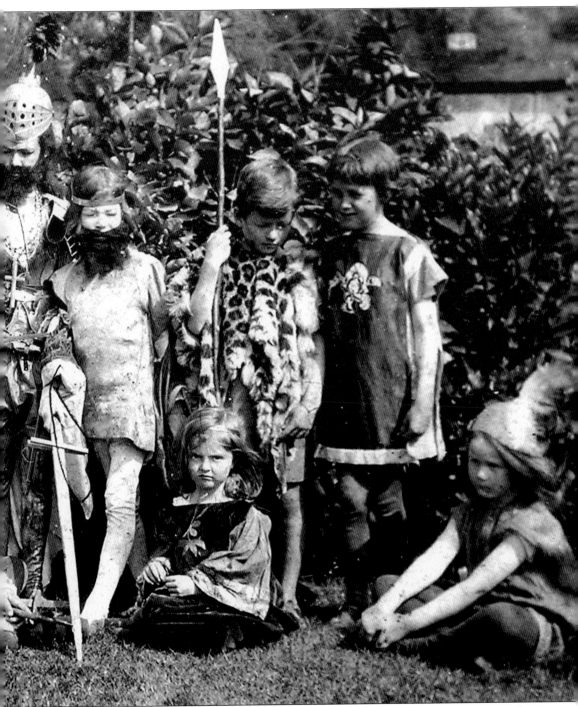

with the cast involved in a production of Sir Walter Scott's *Ivanhoe*. Pictured from left to right are the following: (seated) unidentified, Arvia MacKaye, Allyn Cox, Mabel Churchill, and Caroline Cox; (standing) Ruth Hapgood, Charlie Fuller, Sylvia Hyde, Clara Fuller, Leonard Cox, two unidentified boys, and Edwin Prellwitz. (Courtesy SGNHS.)

Here, Lucia Fuller and her daughter pose for Henry Fuller's painting *Illusions*, which won a medal at the Pan-American Exposition in 1901. In the final painting, Fuller included a view of Mount Ascutney and the Connecticut River. Lucia wrote and directed the *Ivanhoe* production, and it was performed in Frances Houston's spacious living room on September 17, 1904. That day Lydia Parrish entered the following notation in her diary: "It was really wonderful! Over a hundred people. The children and the scenery were so pretty. . . . Lucia Fuller . . . was a marvel and the enthusiasm of the audience must have repaid her for the vast amount of care and thought she had put in the performance. She says being so near blind this summer that the work has been her salvation." It became traditional for the Colony children to present a play each summer. Their artistic parents believed that such pastimes kept their children creatively occupied, and so their performances were wholeheartedly applauded by a full house. (Courtesy SGNHS.)

Ethel Barrymore agreed to direct the Colony children in William Thackeray's comedy *The Rose and the Ring* while she was in summer residence in 1906. The performance was staged in Henry Walker's studio, and tea was served after the show. Louise Cox designed the costumes and Lucia Fuller did the scenery. In *Memories*, her autobiography, Barrymore fondly recalled the production, especially the performances of Clara Fuller and Ruth Hapgood. (Courtesy SGNHS.)

The Rose and The Ring

A PLAY IN IV ACTS

INTRODUCTION—Front of Valoroso's House.
ACT I. Scene 1—Hall in Palace. Scene 2—The Same.
ACT II. The Same.
ACT III. Scene 1—A College Yard. Scene 2—The Same,
 Two Years Later.
ACT IV. Scene 1—Front of Valoroso's House.
 Scene 2—The Same.

CAST

King Valoroso	Leonard Cox
Prince Giglio	Sylvia Hyde
Prince Bulbo	Charles Fuller
Hedzoff	William Platt
Gambabella	Margaret Littell
Porter Gruffanuff	Robin MacKaye
Archbishop	Allyn Cox
Page	Philip Herrick
Army	Roger Platt
Court Lady	Arvia MacKaye
Fairy Blackstick	Caroline Cox
Queen	Clara Fuller
Princess Angelica	Ellen Shipman
Betsinda (Pr. Rosalva)	Sylvia Platt
Countess Gruffanuff	Robert Littell

Prologue recited by Allyn Cox.

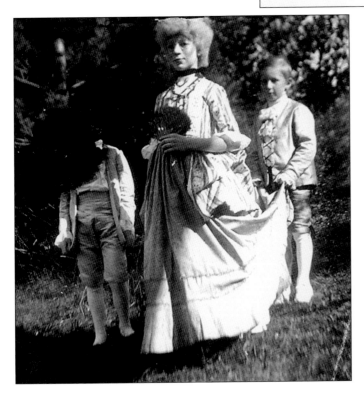

Dressed in their ingenious costumes for *The Rose and the Ring*, Robert Littell (who in 1934 would publish a novel based on life in the Colony) makes a dramatic entrance as Countess Grugganoff (center), while Philip Herrick, as the Page, carries "her" train. The identity of the child hiding behind the ink spot is not known. (Courtesy SGNHS.)

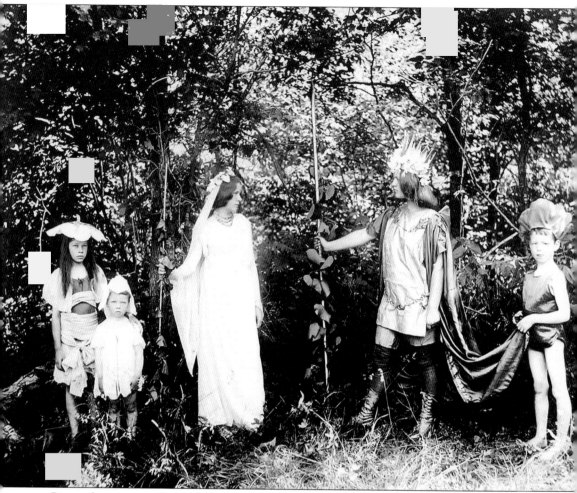

Pictured in a scene from Shakespeare's *A Midsummer Night's Dream* are, from left to right, Margaret Littell (age 10) and Evan Shipman (4 1/2) as fairies; Sylvia Hyde (age 13) as Titania; Clara Fuller (14) as Oberon; and Whittemore Littell as Mustard Seed. All these children gathered together for a performance in July 1909. According to custom and tradition, the costumes were meticulously made, with attentive care to charming detail. (Courtesy SGNH.)

Six

COLONY GARDENS
OUTDOOR LIVING ROOMS

Art historians note that garden design provides an excellent index of a period's beliefs and tastes. In 1924, Ruth Standish Nichols, a pioneer landscape architect and garden historian, whose works are reprinted today, wrote:

"Few parts of New England bear so strong a resemblance to an Italian landscape as the hills rising above the banks of the Connecticut River opposite the peaks of Mount Ascutney. Here in the township of Cornish . . . charming gardens were created by struggling artists who hardly knew the commonest flowers by name, but who were thoroughly conversant with the principles of design. . . . An intense love of beauty, as expressed in both art and nature, and a genuine community spirit were the mainsprings of action."

Some of that "action" exists in the daily log of artist and etcher Stephen Parrish (Maxfield's father), who accepted the principle that gardens were outdoor living rooms that encouraged sociability. From 1893 to 1911, Stephen Parrish crammed his journal with meticulous descriptions of weather conditions and all his gardening activities. From Colonist Ellen Shipman, a professional garden architect with numerous significant commissions throughout the United States, we discover that, "When a number of us were dining with Maxfield Parrish, the talk had been so continually upon plants and diseases, that Parrish rose, put his hands on the table, leaned over, and intoned in a deep voice, 'Let us spray.'"

Although most Cornish gardens were not enclosed, the gardeners of the Colony would have appreciated the first stanza of a poem written by their contemporary William Morris: "I know a little garden close / Set thick with lily and red rose, / Where I would wander if I might / From dewy morn to dewy night." Here an unidentified young girl enjoys the poolside at the Evarts home. (Courtesy WHS.)

In addition to the fountain seen in the previous photograph, a topiary hedge is visible in the distance. Pruned evergreens lined the driveway at the home of William Evarts and provided a barrier to both sight and dust. Mr. Evarts was chief counsel to Pres. Andrew Johnson during his impeachment proceedings, and he served as secretary of state under Pres. Rutherford B. Hayes. (Evarts also was the subject of a handsome marble bust by Augustus Saint-Gaudens.) Presumably Evarts borrowed the idea of topiary from the many formal gardens he visited during his travels abroad. (Courtesy WHS.)

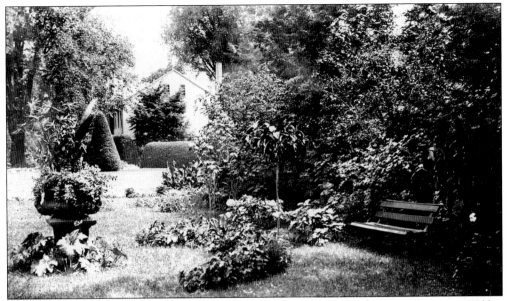

Many prominent dignitaries visited William Evarts in Windsor, and they must have enjoyed his pleasant gardens. From this bench, nestled in a shady nook, it was easy either to admire the ferns and lilies, or to curl up with a good book. (Little could Evarts have known of grandson Maxwell Perkins's future commitment to books as a renowned editor.) (Courtesy WHS.)

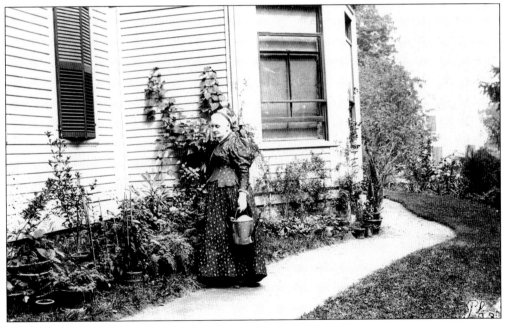

Helen Evarts, a lifelong avid gardener, indicates that there are other things to gardens and gardening besides wandering in them "from dewy morn to dewy night" (in the words of poet William Morris). Her potted plants have been moved from an adjacent greenhouse so that the house can shade them from the scorching summer sun. Still, potted plants need frequent watering, and Helen pauses from her gardening chores to pose for the photographer. (Courtesy WHS.)

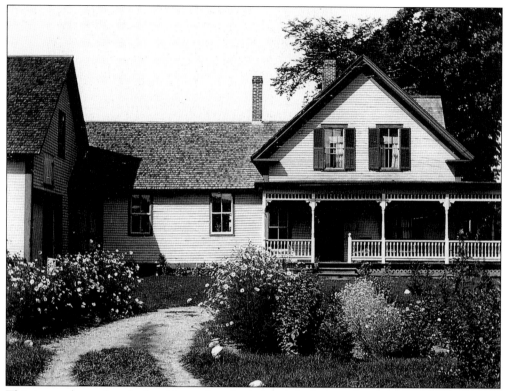

This image shows that the local love of gardening and the loving planning of gardens were not restricted to members of the Cornish Colony. F. J. Franklyn, a pastor of the former Baptist Church in Cornish Flat, took this picture (which he noted was a "south view") of Crescent Drive Cottage, located just across the street from his church. (Courtesy CHS.)

While Stephen Parrish's children Ned, Harry, and Fred (whom we know as Maxfield) were still young, their father presented them with a sketchbook of cartoons. Stephen is the central figure in this drawing of a botanist patiently gathering specimens. It foreshadows his gardening avocation and confirms France Grimes's belief that Parrish "painted as naturally, easily and constantly as a bird sings, with no desire to be considered a great artist." (Courtesy Dartmouth College Library.)

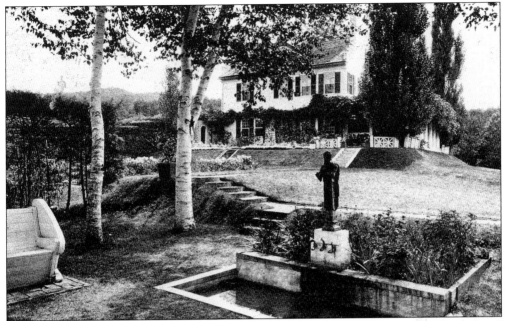

This photograph of the gardens at Aspet shows a sculpture of Pan, which was probably purchased during one of Augustus Saint-Gaudens's trips to Italy. The sculpture was a suitable adornment for a reflecting pool near the Little Studio at Aspet. Perhaps inspired by Pan's pipes, Saint-Gaudens often sang while he worked. Pools such as this were incorporated into many Cornish Colony gardens; some were embellished with fountains or water plants. (Courtesy CHS.)

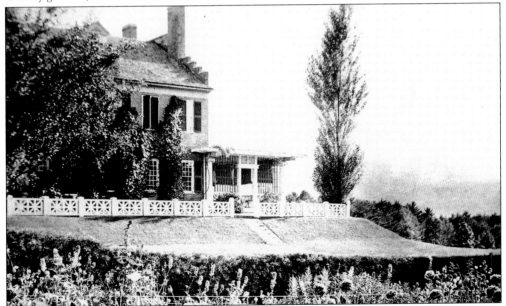

This photograph of Aspet was taken in 1902, before the brick exterior was painted white. A poplar leads the eye to a view of Mount Ascutney, and the fence provides transition between the house and gardens. Saint-Gaudens's garden was an extension of his notion of beauty, yet he also believed that "nature no matter how superb, when it lacks the human element, lacks the vital thing." (Courtesy MacKaye/Ober family.)

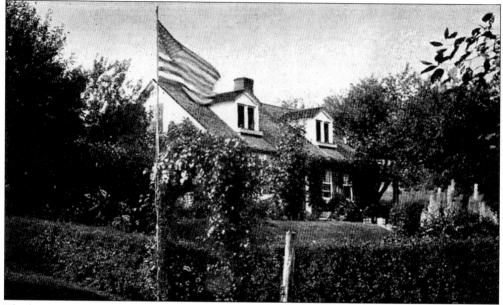

The lupines and clematis abloom in William Howard Hart's garden suggest that this photograph was taken in late June. Hart was a friend of French Impressionist Claude Monet. Hart frequently visited Giverny, France, where he would paint *en plein air* with Monet. The French artist's pastel palette influenced Hart in his use of color, in both his art and his gardens. (Courtesy CHS.)

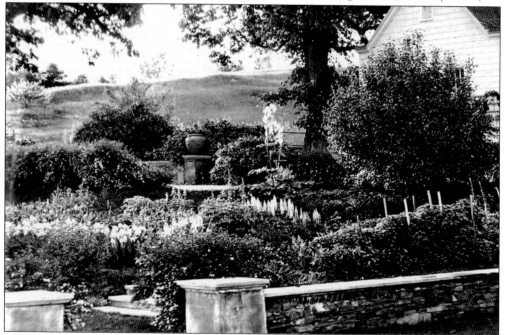

Pictured here in June 1910, the gardens at The Oaks were perfect for wandering. Maxfield Parrish displayed the skill Cornish gardeners were noted for, namely, taking advantage of the natural setting. Regarding this photograph, Mrs. Parrish noted: "Please notice my iris, lupines, gas plant, lilies, and rhubarb in bloom. The hedge of the bridal wreath is also in bloom." (Courtesy Dartmouth College Library.)

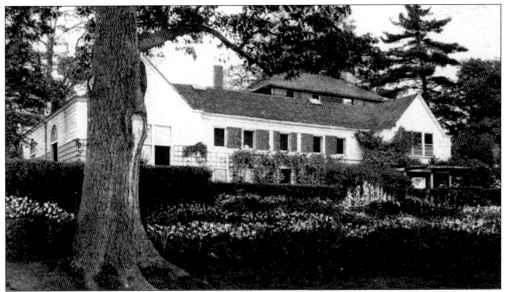

Maxfield Parrish rejoiced in his garden at The Oaks. This is a bank of spring bulbs in bloom and an oak trunk, which Parrish made reference to in a letter to Irénée du Pont, a friend and patron: "As you descend some steps from the upper level to the house terrace, through old oak trunks and branches, you have a confused sensation that there is something grand going to happen." (Courtesy Nichols House Museum, Boston.)

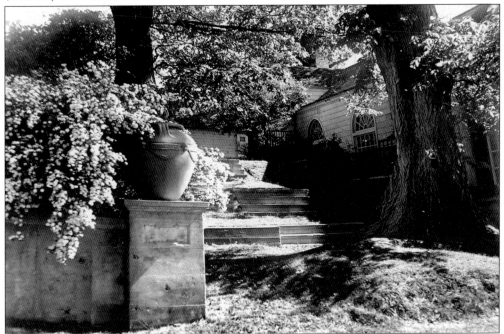

In about 1920 Maxfield Parrish took this photograph of his garden steps—beautified by a large red earthenware vase presented to him by Charles A. Platt. Parrish purchased and named his property for its large oak trees, two of which are seen here. He also refrained from planting Lombardy poplars, a favorite of those Colonists who preferred an Italianate atmosphere, because they would have reduced the visual impact of the stately oaks. (Courtesy Dartmouth College Library.)

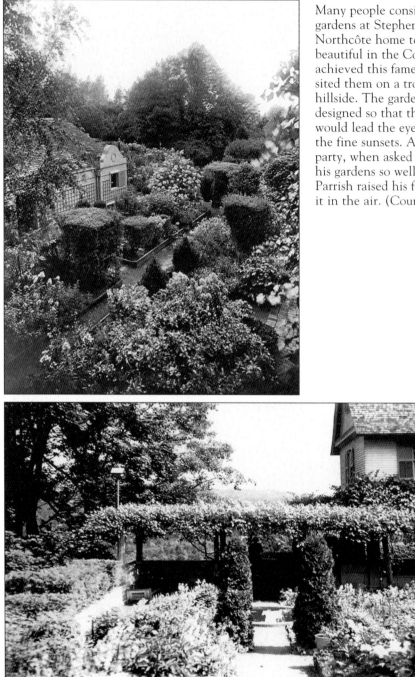

Many people considered the gardens at Stephen Parrish's Northcôte home to be the most beautiful in the Colony. Parrish achieved this fame despite having sited them on a troublesome hillside. The gardens were designed so that the main axis would lead the eye to appreciate the fine sunsets. At a dinner party, when asked how he kept his gardens so well manicured, Parrish raised his fork and waved it in the air. (Courtesy CHS.)

Perhaps inspired by Ernest Harold Baynes's devotion to birds, near his house Stephen Parrish erected a birdhouse to attract feathered friends who would pollinate his flowers and eat unwanted garden pests. Pools, like the one seen behind the trellis here, were features of many Cornish gardens because they added another aesthetic dimension by reflecting clouds and colors from the garden as well as the dance of the sunlight. (Courtesy Dartmouth College Library.)

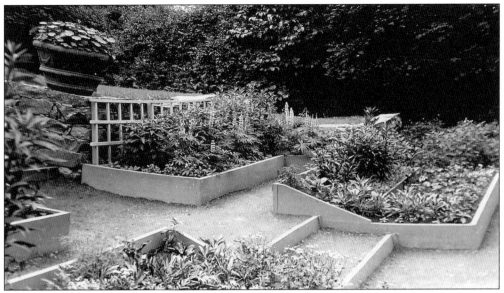

Because of New England's short growing season, Stephen Parrish started his seedlings early in a greenhouse. If one were to visit his gardens early in the growing season, another lesson could be learned: raised beds control root growth and help keep garden paths more free of weeds. At first Parrish filled his beds with annuals, but to no one's surprise, the gardens were later taken over by perennials. (Courtesy Dartmouth College Library.)

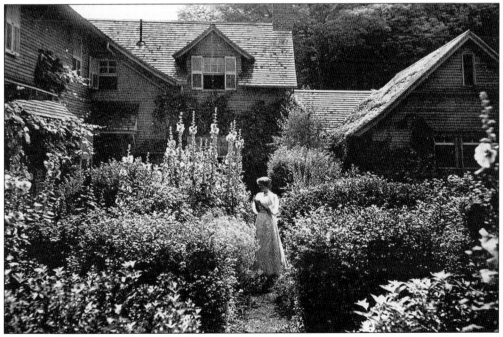

Here Anne Parrish admires the hollyhocks in cousin Stephen's gardens in 1898. By late July the plants provided a spectrum of color sufficient for any artist's palette. Stephen Parrish painted his own garden on several occasions and other Colony floral artists, such as Maria Oakey Dewing and Edith Prellwitz, surely must have been inspired by this garden. (Courtesy Dartmouth College Library.)

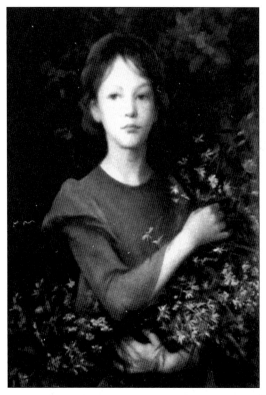

Seen here is Henry Walker's *Girl with Flowers*. Walker's wife, Laura, described the model for this painting (who also was used for *The Gift Bearer*) as "a charming young girl in the neighborhood." While their house was being built, the Walkers boarded with the Tracy family, and Henry used a vacant shop for his studio. They were charmed with their new property, especially the wild flowers, the "wonders of our woods, and our swift rushing brook." Henry captured that enchantment in this painting. (Courtesy Smith family.)

When caring for both husband Henry, who was confined to a wheelchair in his later years, and her handicapped son, Oliver, Laura Walker was left with little time for art—yet she had four exhibitions of her panels in seven years. A reviewer wrote in 1928: "Mrs. Walker may be termed a painter . . . she uses her silk thread [and] silk fabric much as though they were a pigment. Flowers are given realistic settings of receding landscapes." (Courtesy Smith family.)

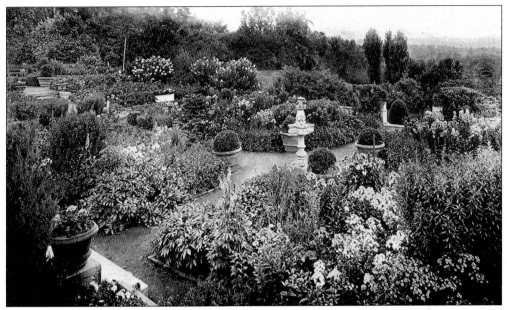

This overview of Charles Platt's garden in Cornish was featured in the magazine *Beautiful Gardens*. The photograph was taken from the grassy terrace in front of the house. Across the way are mountain vistas, but unlike many Colonists, Platt did not deem Mount Ascutney to be an essential focal point. His 1894 study, *Italian Gardens*, emphasized the intimate connection between a house's design and the outside environment. (Courtesy CHS.)

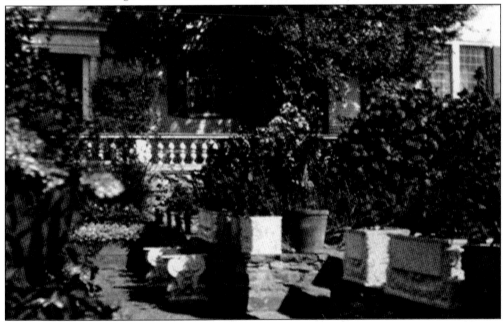

Charles Platt wrote, "The garden was designed as another apartment . . . where one might walk about and find a place suitable to the hour of the day and feeling of the moment, and still be in that sacred portion of the globe dedicated to one's self." Many contemporaries applied Platt's concept of the garden as an outdoor living room. Perhaps Louise Cox took this picture for inspiration. (Courtesy SGNHS.)

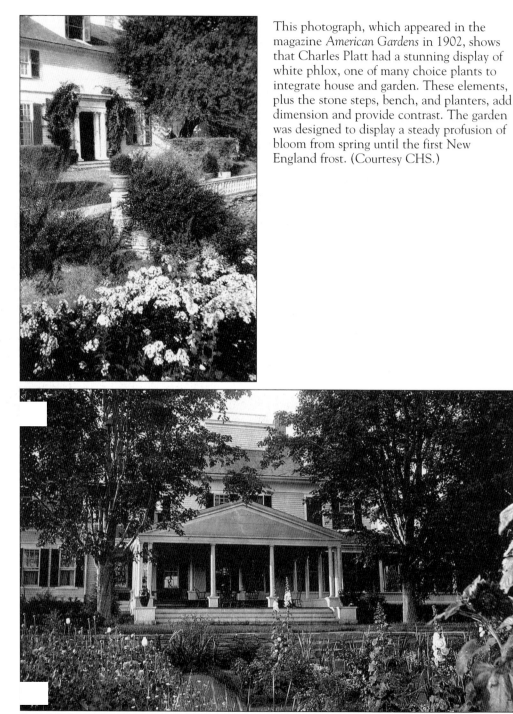

This photograph, which appeared in the magazine *American Gardens* in 1902, shows that Charles Platt had a stunning display of white phlox, one of many choice plants to integrate house and garden. These elements, plus the stone steps, bench, and planters, add dimension and provide contrast. The garden was designed to display a steady profusion of bloom from spring until the first New England frost. (Courtesy CHS.)

One of Platt's protégées was Rose Nichols, a niece of Augusta Saint-Gaudens. Nichols used her garden at Mastlands as a laboratory and subject for many of her articles on gardening and her important studies of garden history. She enclosed her garden with a fieldstone wall, into which she built seats, and aligned gravel pathways around an apple tree that was the focal point of her garden. (Courtesy Nichols House Museum, Boston.)

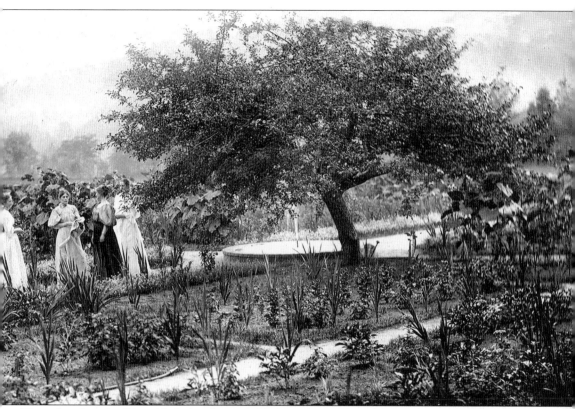

These four friends of Rose Nichols, who probably knew her well enough to call her "Rosy-Posey," could be surveying her garden at Mastlands to determine the extent to which she followed her own advice. This is how one contemporary observer put it: "Miss Nichols is doubtless best known as the author . . . with an unusual degree of care and intelligence. But to write of gardens is one thing, to make them another. There be many garden writers who say unto the reader 'Lo here' and 'Lo there' is the place to plant, but their actual knowledge of the subject is slenderness itself. Rare indeed is it when in garden matters precept and practice are met together in the same person. For which reason, it is refreshing to know that Miss Nichols can make a garden as well as books about them and her garden at Cornish was well worth making." (Courtesy Nichols House Museum, Boston.)

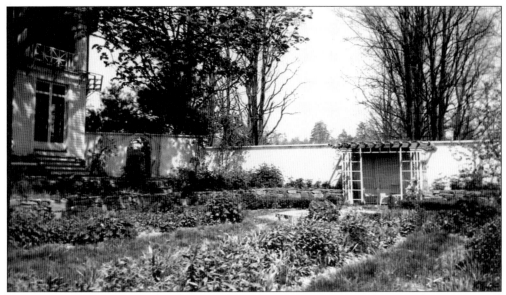

The stone wall at Winston Churchill's Harlakenden was an important feature. Also, fencing and a covered pavilion connected the house and garden in accordance with Charles Platt's ideal of the garden as an outdoor living room. An arched doorway, on the left, provided an inviting entrance to the garden. In this secluded garden the Churchills utilized both sun- and shade-loving plants to accommodate the lighting conditions. (Courtesy Dartmouth College Library.)

At the end of his life, Winston Churchill turned from writing novels to creating art. Although he suffered from writer's block, he had a keen eye for landscape design and saw to it that trees were cleared to create new gardens and open vistas on his 700 acres. Surely President Wilson and his family enjoyed the peonies when they bloomed in this garden. (Courtesy CHS.)